REVERE
THROUGH TIME

WILLIAM J. CRAIG

AMERICA
THROUGH TIME®
ADDING COLOR TO AMERICAN HISTORY

This books is dedicated to John Craig and Anne Fedele. Anne was a founding member of Revere Society for Cultural and Historical Preservation. The many organizations that she tirelessly donated her time and effort are better for having known her, and to those of us lucky enough to have called her our friend will always treasure the time she spent with us. John was a second generation Revere native who spent his entire 84 years of life in the City of Revere except for 4 years in service with the USAF during the Korean Conflict. He loved the city and its residents and could be found rooting on the RHS football team every Thanksgiving Day. He was a member of many local benevolent organizations as well as active in local politics. To many he was considered to be all that was and is good and decent about Revere.

America Through Time is an imprint of Fonthill Media LLC
www.through-time.com
office@through-time.com

Published by Arcadia Publishing by arrangement with Fonthill Media LLC
For all general information, please contact Arcadia Publishing:
Telephone: 843-853-2070
Fax: 843-853-0044
E-mail: sales@arcadiapublishing.com
For customer service and orders:
Toll-Free 1-888-313-2665

www.arcadiapublishing.com

First published 2019

Typeset in Mrs Eaves XL Serif Narrow
Printed and bound in England

INTRODUCTION

The city of Revere is comprised of 3,750 acres along the Atlantic Ocean and is situated midway between the cities of Lynn and Boston. The geographic area that is currently called Revere was first known as Rumney Marsh. The earliest inhabitants of this area were the Rumney Marsh Indians belonging to the Pawtucket Tribe of a great nation called Aberginians. The Indians would hunt and fish along the beach and along the banks of the Saugus River and Pines River.

One of the earliest grants of the Great Council for New England was awarded to Robert Gorges, the brother of Sir Ferdinado Gorges. The land grant was issued on December 30, 1622. The grant extended from the Charles River ten miles north toward Salem, and included Charlestown, Chelsea, Winthrop, East Boston, and Revere. Robert Gorges came over as a lieutenant general and governor. He returned to England the following year, leaving his affairs with an agent. Many historians believe that the agent was Samuel Maverick, who arrived in Winnisimmet around the year 1624.

There is further evidence that Samuel Maverick and Robert Gorges had a connection. A grant of Agamenticus on December 2, 1631, was made to Sir Ferdinado Gorges and eight other men from New England, Samuel maverick among them.

The Great Allotments of Rumney Marsh and Pullen Point were recorded on January 8, 1637–1638. There were twenty-one allotments handed out to Boston's most prominent citizens. They were as follows: Sir Henry Vane, John Winthrop the Elder, James Penn, John Newgate, John Sanford, Thomas Marshall, Thomas Matson, Benjamin Gillam, John Gallop, Robert Keayne, John Coggeshall, John Cogan, Robert Harding, Nicholas Willis, John Odlin, Richard Tuttle, Mr. Glover, William Dyar, Samuel Cole, William Brenton, and William Aspinwall. By 1639, only five of the original allotters retained their lands and all five added to them through purchase. Sir Henry Vane's allotment was sold to Nicholas Parker, and William Aspinwall's to James Penn. The only original land grantees left were John Newgate, Robert Keayne, John Cogan, Richard Tuttle, and Samuel Cole. Even though these seven men owned what is now known as Revere, they were nonresident proprietors. They had their main residences elsewhere and either leased the land to tenant farmers or used the land as a hunting lodge.

By 1775, what is now known as Revere was a thriving village. The days of tenantry were over and farming was the main occupation. Nearly all the woodlands had disappeared and the land was cultivated. A school, church, and roads had been established. There was also a thriving fishing industry located at Newgates landing which was located at the Slades Mill site. When the American Revolution began, Parson Payson could be seen

drilling the men of the Revere Militia on the church green. On May 27, 1775, the second military engagement and the first naval battle of the Revolutionary War took place and became known as the Battle of Chelsea Creek.

For years after the Revolutionary War, Rumney Marsh (Revere), Winnisimmet (Chelsea), and Pullen Point maintained its relative importance with the meeting house and the town offices being at Rumney Marsh. In 1831, the Williams Farm with the ferry franchise was purchased by trustees who conveyed their estate, in 1833, to the recently incorporated Winnisimmet Company. In 1835, the company purchased the Shurtleff Farm and several other large estates, which they divided into house lots. A considerable population increase occurred and on March 19, 1846, became the town of Chelsea; Rumney Marsh and Pullen Point became known as a separate town named North Chelsea. The name of North Chelsea was changed to Revere on March 24, 1871, to honor Paul Revere, the Revolutionary War patriot.

Perhaps the most important part of Revere's history has been the three-mile crescent beach. Beginning in the 1830s, many businessmen came to the beach section of Revere and built commercial developments on the beach and the Point of Pines. These amusement and hotel developments helped to give Revere the title "The Playground of New England."

As the beach developed into a World Class entertainment venue with its ballrooms and A-list celebrities and performers, the city grew and prospered. By the 1970s, the beach had suffered from several fires and neglect—the glory days were far behind the city of Revere. Over the next thirty years, the beach underwent a form of urban renewal as well as the rest of the city, helping to bring it into the twenty-first century.

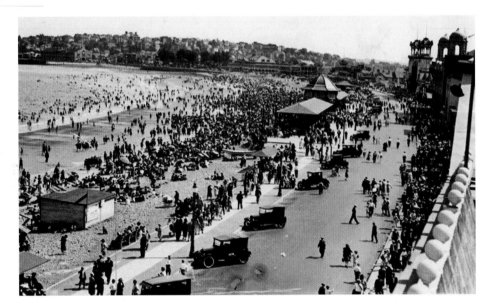

REVERE BEACH IN ITS HEYDAY: The beach is over three miles long. In 1875, a rail link was constructed to the beach, leading to its increasing popularity as a summer recreation area, and in 1896, it became the first public beach in the United States.

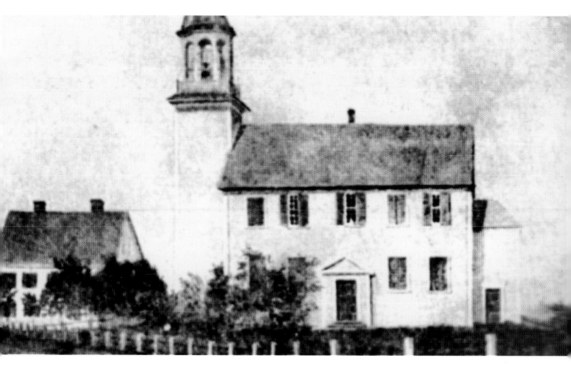

CHURCH OF CHRIST: The first church in Rumney Marsh was the Church of Christ, dedicated in 1710. The church was located on the Country Road which is now named Beach Street. From 1710 until 1805, the church building was also used as a town meeting house. The church was originally supported by the town. The building originally faced Beach Street; however, when it was remodeled in 1856 the building was turned about a quarter of the way to its present location. The slave entrance and main entrance were closed during this renovation. The building was again remodeled in 1887. This is the oldest church building in Suffolk County and is currently being used as a community mental health facility.

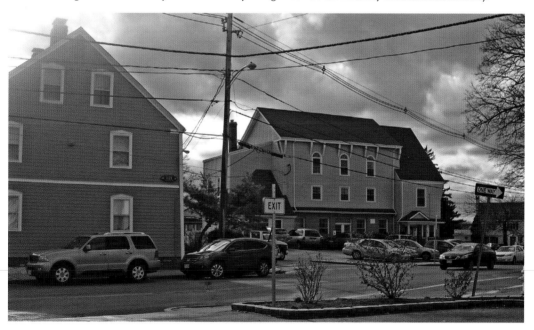

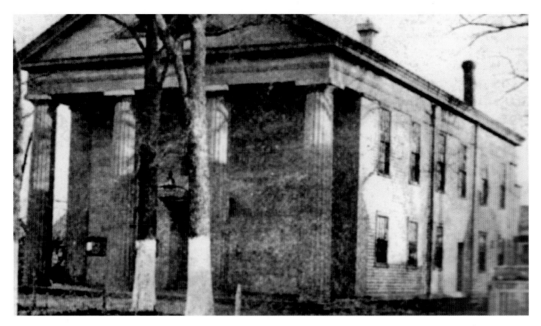

FROM CITY TO TOWN HALL: The original Town Hall was built in 1835 on the site of the present-day City Hall. The land was acquired from John Wright for $150 for a third of an acre. A town committee appropriated $3,000 for the land and the building. The Town Hall had been in use for sixty-two years before being completely destroyed by fire on January 19, 1897. On February 8, 1897, a committee was appointed to build the present-day City Hall. The cornerstone was laid on October 9, 1897, and Senator Henry Cabot Lodge delivered the oration. The building was dedicated on January 11, 1899, and cost $120,000. Today, the City Hall building looks exactly as it did when it was dedicated over a hundred years ago.

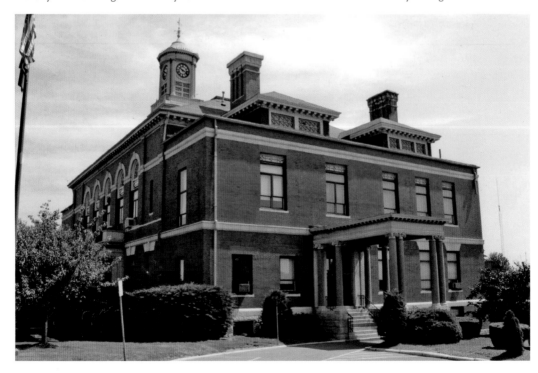

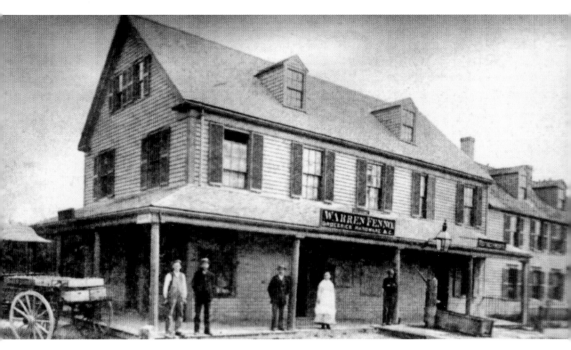

CORNER OF BEACH STREET AND BROADWAY: This building that was erected in 1835 by John Fenno and his son Joseph. Originally, the Fenno family operated a store for the town. In 1849, William Fenno started a stage coach service from Revere to the Ferry Slip. He undertook three trips daily with two extra trips during the summer season. Reverend Horatio Alger was the first post master in Revere and the post office was also housed in this building, along with the second floor, which was being used as a public hall for the town. The building was most recently home to Reardon's Restaurant, which has since closed. The building has since been torn down and replaced with apartments.

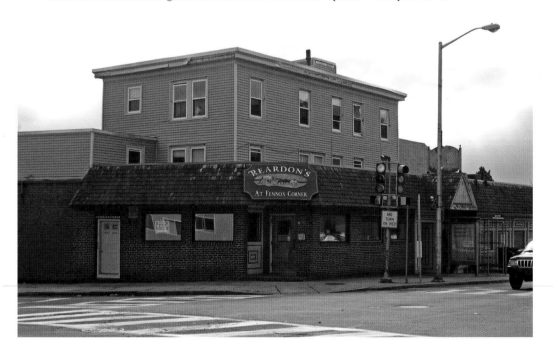

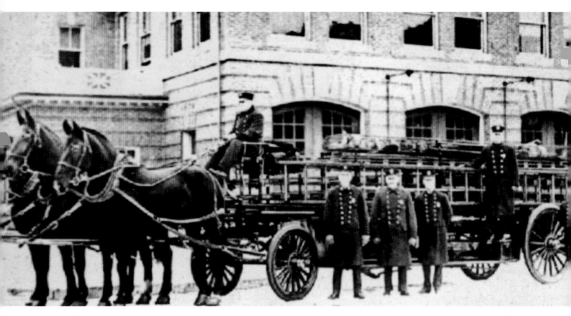

THE REVERE FIRE DEPARTMENT: The department was established as a permanent fixture in the city in 1885. The first fire station was built that same year and was located on the corner of Park Avenue and Broadway. In 1912, a new fire station was built at a cost of $40,000 and was named the Central Fire Station. The original station was torn down once the new station was opened. Above, we see the men who worked on the hook and ladder apparatus standing in front of the newly built Central Fire Station. Below is Central Fire Station on Broadway, looking very much as it did when it opened over a hundred years ago. Gone are the horses and manual wooden doors on the apparatus floor. Today, this fire station serves as headquarters for the Revere Fire Department and is still an active fire house serving the community.

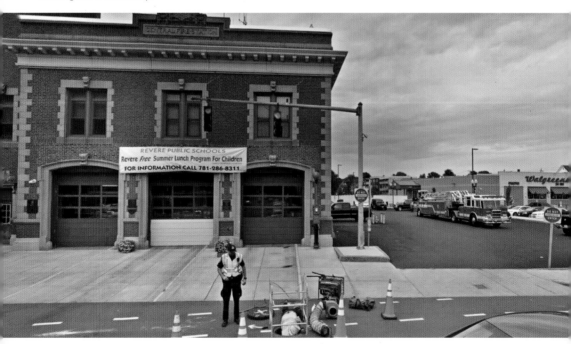

Law and Order in Revere: In 1872, appropriations were made to establish a full-time police department. The first police station was located in a converted engine house on Pleasant Street. Prior to 1873, the constables utilized two cells over an old hearse house. The police station was moved to Hyde Street in 1909; it was converted to a dwelling. The next station was built at a cost of $22,200 and was in use until 2008 when a new police station was built. The building was later razed and the property is used as a parking lot for City Hall. Below, The new Revere Police Station was built on Revere Beach Parkway on a former MDC storage site. The new station opened in 2008 and boasts state of the art holding cells, and facilities with plenty of room for the 109 officers currently on staff. The department currently has an annual budget of $5 million per year.

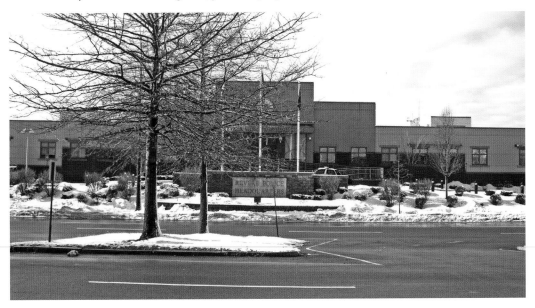

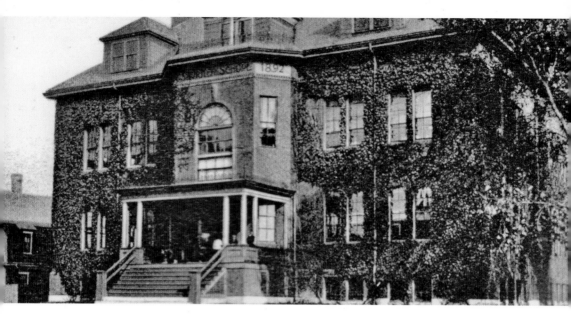

FIRST SCHOOLHOUSE: On May 17, 1749, the first schoolhouse was purchased by the town for ten schillings. The building was located near Beach Street and Central Avenue. In 1805, the building was sold and relocated. Many historians believe that the Barry house, which stood on Broadway, was believed to be the former schoolhouse. A new brick schoolhouse was built in its place. In 1838, Reverend Horatio Alger, chairman of the school committee, informed the town that the schoolhouse was inadequate and a new building was built and named after Dr. Shurtleff. This school was torn down in 1892. Below is the site of the former Shurtleff Schools. The land was acquired of School Street from John Pierce for the sum of $200. The second Shurtleff School served the city from 1892 until the mid-1980s, when it was closed and torn down.

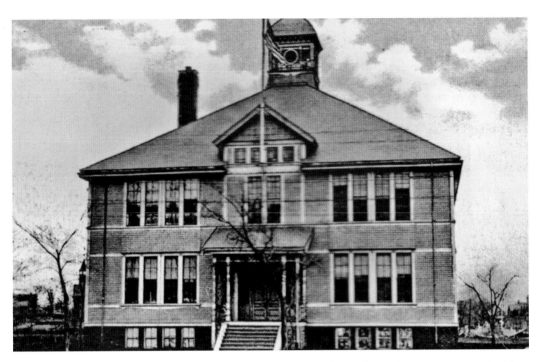

THE WINTHROP AVENUE SCHOOL: Built in 1885 at a cost of $18,300, this eight-room wooden building originally had a second floor which contained four rooms. In 1903, a fire broke out on the top floor, causing severe damage. The second floor was never replaced. Below is a current view of the Winthrop Avenue School. The building was utilized by Revere High School for shop classes until the new high school was built in 1974. The building was then sold to the Revere League of Special Needs and is now utilized by this group for day programs.

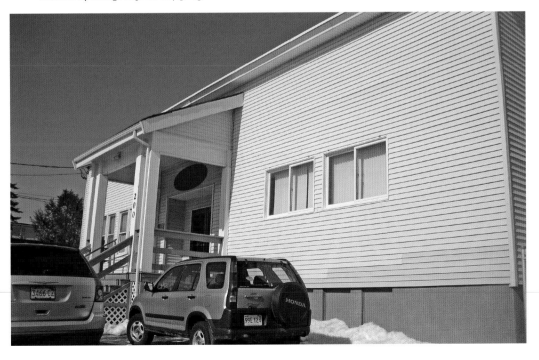

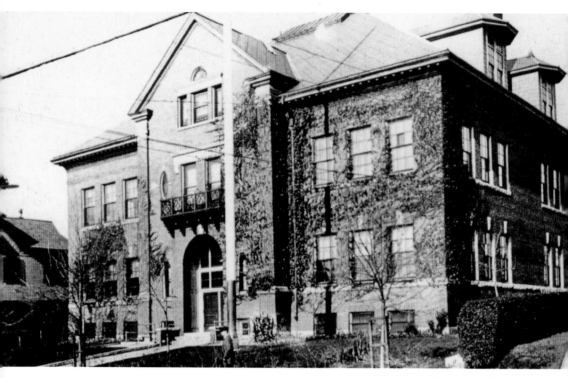

BRADSTREET AVENUE SCHOOL: Originally known as the Bradstreet Avenue School, this building was erected in 1896 and contained eight rooms and an assembly hall. The price of the school was increased due to the cost of litigation between the contractor and the town, raising the total cost to $39,500. The Bradstreet Avenue School underwent a name change and became the Mary T. Ronan School. The building was used as an elementary school until the late 1970s when the school was closed and sold. The building was placed on the National Register of Historic Places in 1981. Currently, the building houses forty apartments and a solarium with views of Boston.

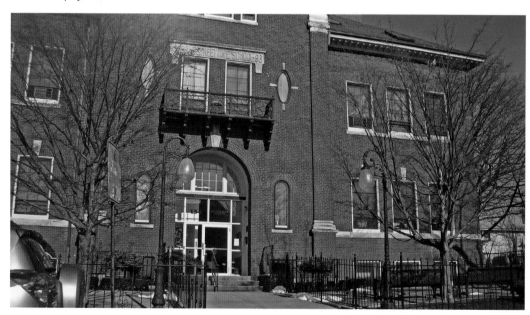

SCHOOL TO TOWNHOMES: The Liberty School was located on Franklin Avenue. The building served as an elementary school for the Shirley Avenue community. The school had fifteen classrooms as well as an assembly hall. The school was closed in the early 1980s. The townhomes below now occupy the site of the former Liberty School. After the school closed it remained vacant for several months until a fire broke out in the building. The building was completely destroyed and later razed. These townhomes were built on the site during the 1980s.

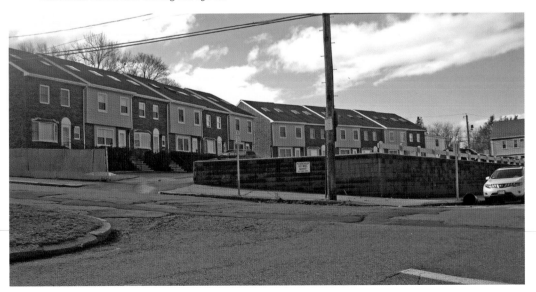

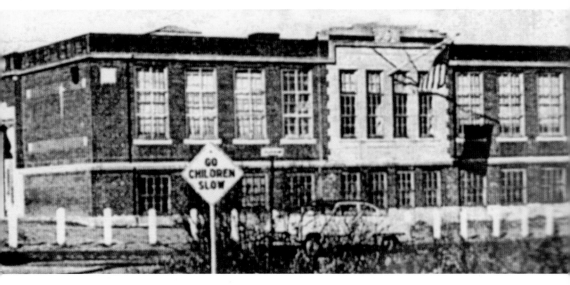

A Park on Former School Grounds: The Louis Pasteur School was located on Leverett Avenue. The building was erected in 1925. It served the Beachmont community as an elementary school. The school had eight rooms and an assembly hall. The school was closed in the 1970s and torn down. After the Louis Pasteur School was razed, the city retained the land the school occupied and built the Louis Pasteur Park (below). The park features basketball courts, playground and picnic tables. This park is now enjoyed by Revere citizens who live nearby.

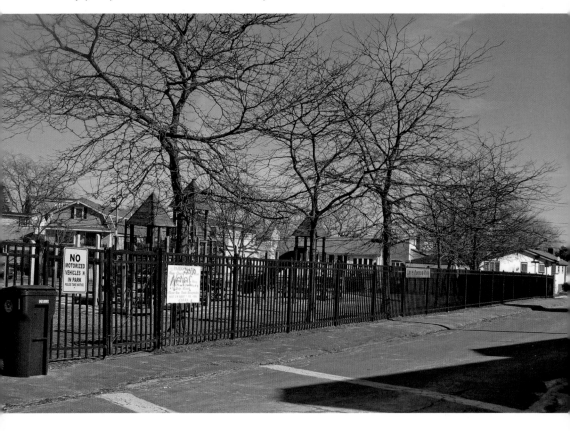

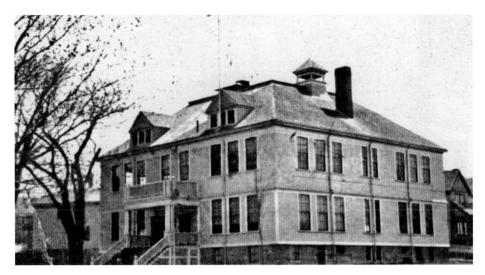

CRESCENT AVENUE SCHOOL: This building was originally known as the Crescent Avenue School. It was later renamed in honor of Julia Ward Howe. The school was built in 1890 and served as an elementary school until it was closed in the late 1970s. In January 1981, a fire broke out in the recently sold former school building. The four-alarm blaze caused significant damage to the building. The new owners tore down most of the structure and rebuilt the new building according to the original building's specifications. The new building is still being used as an apartment complex.

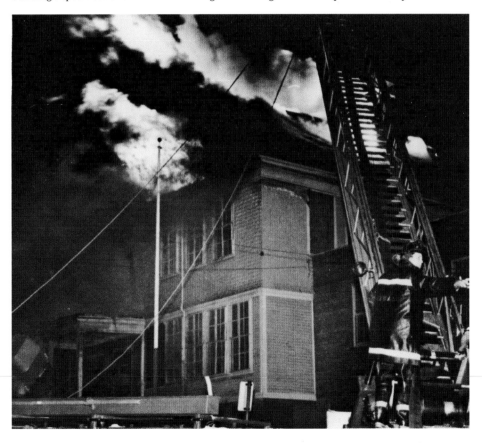

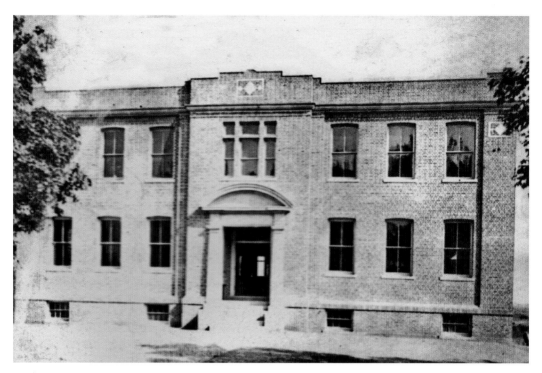

THE HENRY WAITT SCHOOL: Located on Salem Street, the Henry Waitt School was built in 1901 and utilized as an elementary school by the residents of North Revere. The school has since been closed and torn down. The Henry Waitt School site is now occupied by a parking lot for the employees of the nursing home (below). When the Waitt School closed, elementary students who resided in North Revere were taken by bus to other schools in the city.

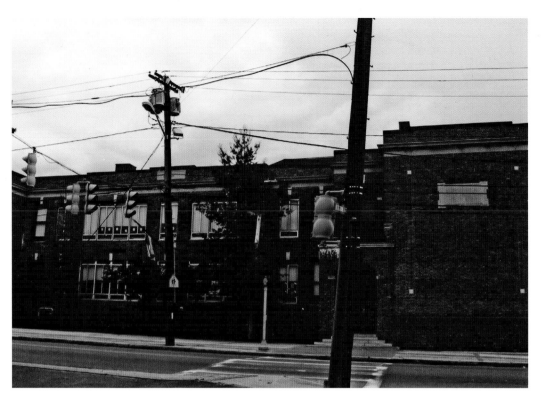

PAUL REVERE SCHOOL: Built in 1903, the building originally only had four classrooms. Through the years, the school had been extensively renovated and added on to. The school had been utilized for over 100 years by Revere students and in 2005 plans were underway to close the school and build a more modern school facility. The new Paul Revere School opened its doors in 2010. The facility was built on the site of the former Paul Revere School. The new building boasts computer labs and modern facilities for students.

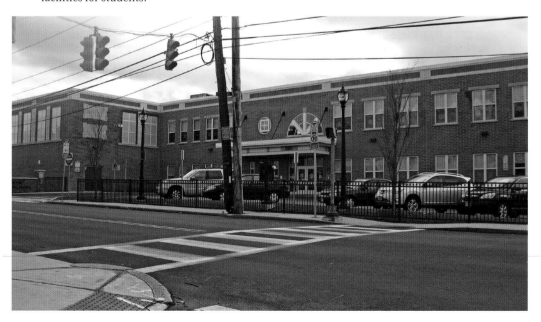

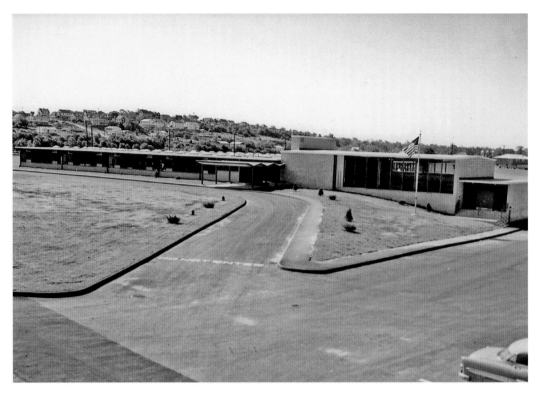

WHELAN SCHOOL: Built in 1957 on former farmland, the school was built to accommodate the growing population of Revere students. In 2005, discussions were underway to close the school and raze it. The new Whelan School and Susan B. Anthony School was built on the former site of the old Whelan School. Originally the Whelan School was designated as an elementary school. When the new school was built, the elementary portion retained the name Whelan School, while the junior high school section took the new name, Susan B. Anthony School.

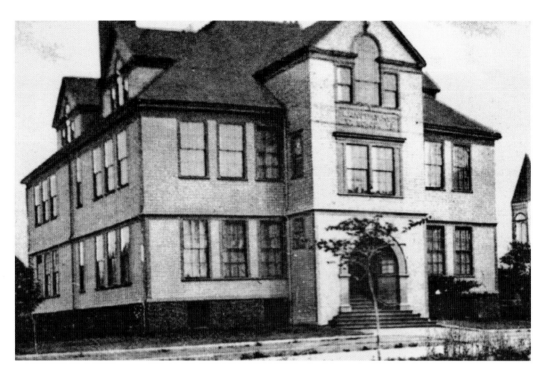

WALNUT AVENUE SCHOOL: The school was first utilized as an elementary school. Then, on June 26, 1901, plans were announced that the building would become the first high school for the city of Revere. The high school was housed in this building until 1908 when a larger facility was built on Beach Street. After the high school moved out, the building was used for several purposes over the years. In 1971, the building was used by the Prince Strauss organization, when it was completely destroyed by fire. After the former Walnut Avenue School was destroyed by fire, the building was razed. Currently the site of the former school is occupied by the Revere Housing Authority property Carl Hyman Towers (below). This apartment complex provides low-income housing to senior citizens and persons with disabilities.

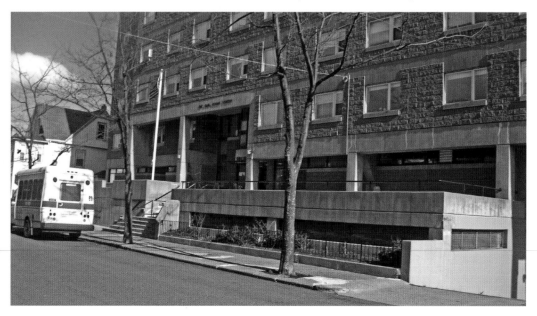

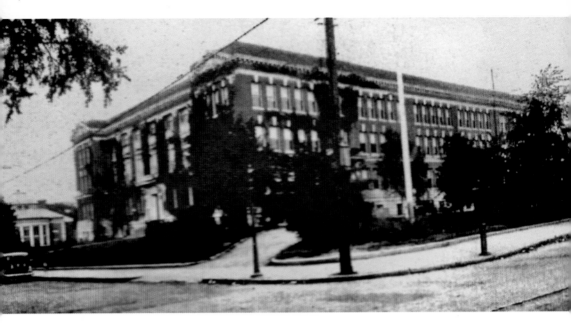

HIGH SCHOOL, PARK, AND CHURCH: In 1908, the second Revere High School was built on the corner of Winthrop Avenue and Beach Street. The school cost a total of $140,000 and contained fourteen classrooms, three laboratories, an auditorium, and offices for the school committee. In 1924, a cafeteria and gymnasium were added. The school was closed in 1974 and primarily used as a storage facility until it was completely destroyed by fire. After the former high school building was torn down, the land which it occupied became Sonny Myers Park and remained so until the Archdiocese of Boston entered into conversations with city officials and eventually a deal was reached. The deal was an even swap of property. The city of Revere would get the former rectory, parking lot, and the dilapidated church building. The Archdiocese of Boston would receive the land that Sonny Myers Park now occupied. The new Immaculate Conception Church opened its doors to parishioners in 1990.

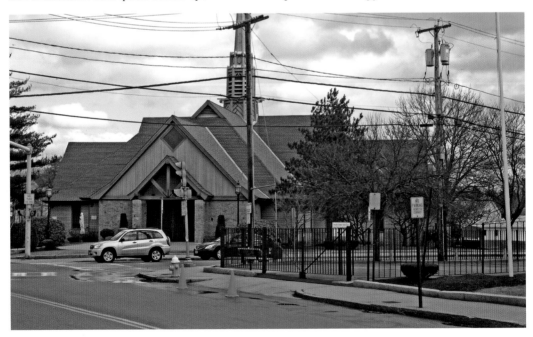

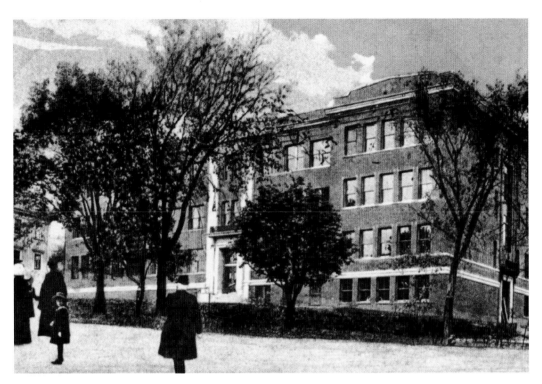

THREE SCHOOLS: In 1911, the Lincoln School was built on the site of the former Malden Street School. An addition was added to the Lincoln School in 1931. Due to the lack of available space at the Revere High School gymnasium, all RHS basketball games were played at the Lincoln School gymnasium. The building was completely destroyed by fire in 1963. Below, the second Lincoln School was built on this site in 1967. It is still in use by students as an elementary school. The high school no longer utilizes the gymnasium for its basketball games. This is the third school to occupy this site.

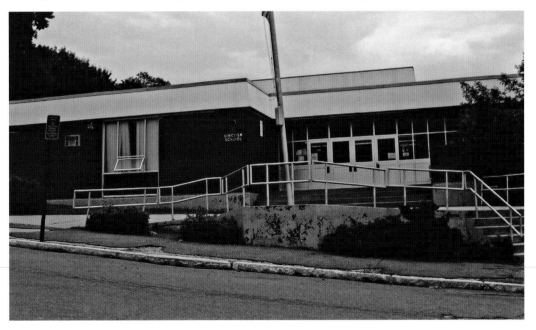

TEWKSBURY SMITH HOUSE: This home was built by Elisha Tuttle in 1690 and is located on School Street. Sixty years later, a man named Hawke purchased the property and opened a tavern in the home. In April 1775, Reverend Payson gathered a group of men at the tavern and headed to Lexington. The men had a skirmish with British Soldiers near Arlington. Payson's men defeated the British and stole their supplies. The home was used as a safe house for men from Vermont and New Hampshire during the Battle of Bunker Hill. The below image shows the Tewksbury Smith House, located at 22 School Street, as it currently looks today. The home has undergone many renovations and additions over the years. In 2001, the current owner began a major renovation project on the property. Three quarters of the home were torn down and all that remains of the original farmhouse is the front façade.

A HISTORIC HOSPITAL: This home was located at 204 Proctor Avenue and was purchased by Dr. Francis Licata. He invested $70,000 to renovate the building and named it Revere General Hospital. Originally, the building had twenty-six beds, an emergency room complete with a driveway on Mountain Avenue, x-ray room, pharmacy, delivery room, and an operating room. The hospital had a maximum capacity of thirty-six patients and opened on September 25, 1939. In 1948, it was sold and renamed Revere Memorial Hospital in honor of Revere's veterans. In 1963, a three-story wing was added on to the hospital. Once the hospital was sold in 1948, the new administration began a capital improvement campaign. They immediately began to raise funds to expand and modernize the facility. The original building was eventually razed and a new building was erected. The hospital operated until 1968, when it closed due to fiscal problems. During the 1970s, it was used as a hotel for U.S. Naval personnel on leave during the Vietnam War. Today, the building looks very much the same as it did when it was a hospital. Currently, the building is being utilized as a nursing home.

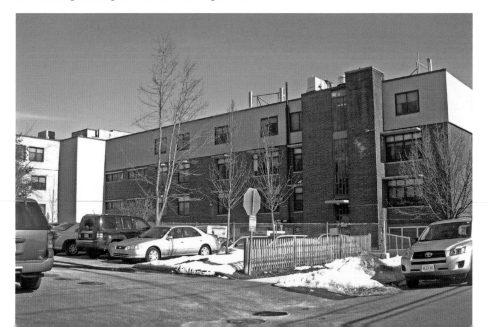

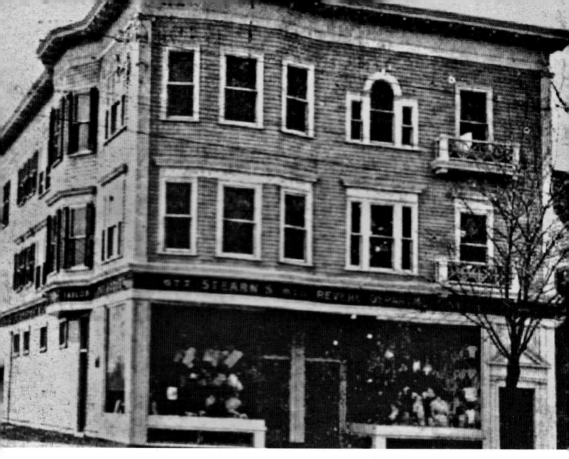

STEARNS DEPARTMENT STORE: The above building is Stearns Department Store on Beach Street. Stores like this sold household appliances, dresses, suits, and assorted sundries. Businesses like this catered to every need of their shoppers. It is unknown what years this business operated in this location. However, the Stearns name later on became well known as a local Hardware Store. It is unknown whether or not the Stearns Department Store was connected to R. H. Stearns Department Store of Boston. The below image shows the former Stearns Department Store building as it currently looks today. The building still occupies its original site and is now being utilized as a rooming house. The building has not really changed since it was Stearns Department Store.

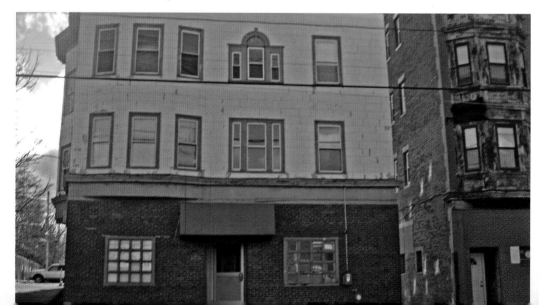

Historic Mill Building:

The residents of Rumney Marsh petitioned the selectmen of Boston for the right to build a tidewater mill in 1721. The selectmen granted the petition but attached so many restrictions that nothing was done until 1734, when Thomas Pratt built the mill at his own expense. The mill was destroyed by fire in 1816. The town bought out Pratt's interest and built a new mill on the same site. In 1827, Henry Slade acquired the mill, which he used to grind snuff and corn. In 1837, Henry Slade's sons conceived the idea to grind spices. For the next 130 years, Slades Mill became well known for spices. The Slades closed in the late 1960s and the building sat abandoned. In 1972, the building was placed on the National Register of Historic Places. Currently the building is being used as office space.

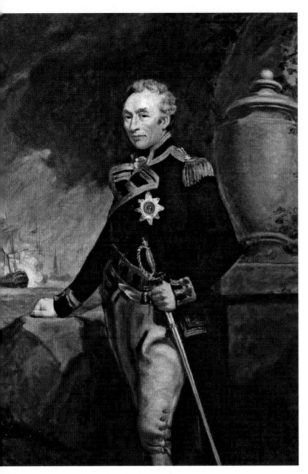

HMS *Diana*: On May 27 and 28, 1775, the battle of Chelsea Creek was fought between the colonists and the British Navy. This was the first naval battle in United States history. During the siege of Boston, the colonists engaged in the moving of cattle and hay from Beachmont, Noddles, and Hog Islands. The British vice-admiral Graves ordered the schooner HMS *Diana*, which was commanded by his nephew Thomas Graves (pictured above), to go up Chelsea Creek and cut off the colonial forces who were led by John Stark. The schooner *Diana* ran aground, refused to surrender to American forces, and was eventually abandoned. The colonists boarded the ship and removed everything of value, including sails, rigging, clothing, money, and cannons. It is believed that the cannons were used by the American forces at the Battle of Bunker Hill. They then laid hay under the stern and set the ship ablaze to prevent the British from salvaging the ship. Today there is marker near the site of this historical event.

The view below from a contemporary watercolor looks across toward Revere from Beacon Hill, Boston.

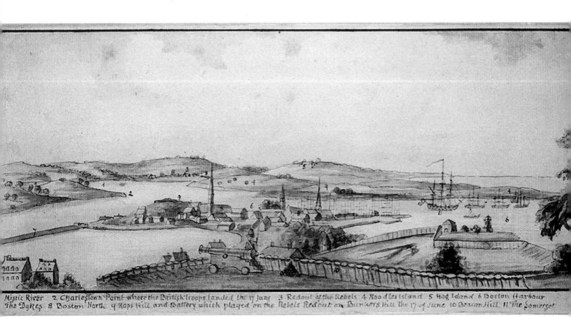

1 Mistic River 2 Charlestown Point where the British Troops landed the 17 June 3 Redout of the Rebels 4 Noodles Island 5 Hog Island 6 Boston Harbour 7 The Dykes 8 Boston North 9 Cops Hill and Battery which played on the Rebels Redout on Bunkers Hill the 17 of June 10 Beacon Hill 11 The Somerset

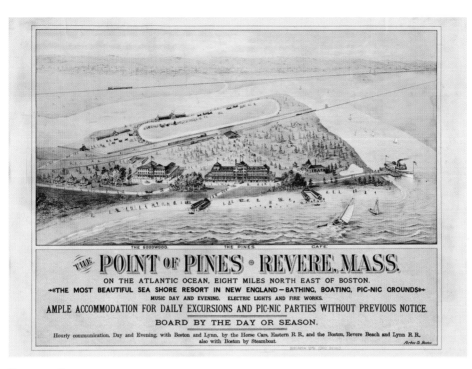

THE GOODWOOD. THE PINES. CAFE.

THE POINT OF PINES · REVERE, MASS.

ON THE ATLANTIC OCEAN, EIGHT MILES NORTH EAST OF BOSTON.
THE MOST BEAUTIFUL SEA SHORE RESORT IN NEW ENGLAND – BATHING, BOATING, PIC-NIC GROUNDS
MUSIC DAY AND EVENING. ELECTRIC LIGHTS AND FIRE WORKS.
AMPLE ACCOMMODATION FOR DAILY EXCURSIONS AND PIC-NIC PARTIES WITHOUT PREVIOUS NOTICE.
BOARD BY THE DAY OR SEASON.
Hourly communication, Day and Evening, with Boston and Lynn, by the Horse Cars, Eastern R. R. and the Boston, Revere Beach and Lynn R. R., also with Boston by Steamboat.

POINT OF PINES: In 1881, Senator Henry Cabot Lodge and Senator Saltonstall formed a company with other businessmen and purchased 200 acres of land at the Point of Pines section of Revere. They built a premier resort, with a hotel, restaurant, bandstand, racetrack, pier, bath house, and amusements for the total cost of $500,000. In 1912, the Bull Moose Party gathered at the hotel to hear former president Theodore Roosevelt speak. The resort closed in 1913 and the hotel was torn down in 1914. A portion of the property was utilized as an airport during the 1920s and the racetrack was used up until 1933, for auto racing. *Inset:* The Point of Pines Hotel, an early postcard view. *Below:* The aerial view of the Point of Pines shows that the area became a residential neighborhood in the years after the closing of the resort. *Massachusetts 2013-2014 USGS Color Ortho Imagery, licensed under Creative Commons*

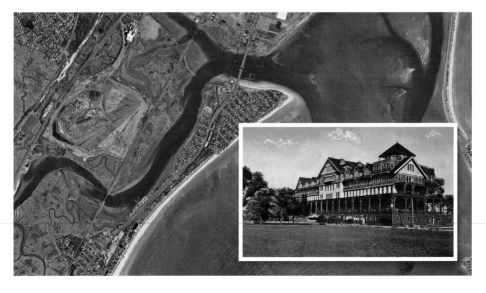

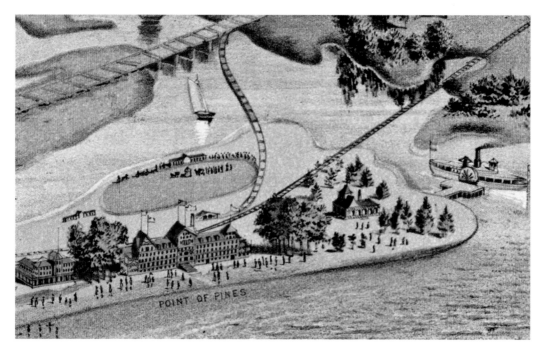

POINT OF PINES: The above image is an artist rendition of the resort that was located at the Point of Pines at the turn of the century. The image even shows the rail lines and steamer service from the North Shore to assist patrons who were vacationing at the hotel. Below is an aerial view of the General Edwards Bridge and the yacht club at the Point of Pines. In the upper right-hand corner we can see how the area has transformed over the past 100 years into residential subdivisions and rail and steamer service has been replaced by roads and bridges.

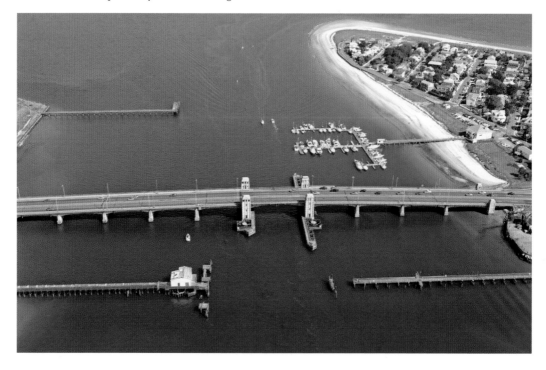

REVERE BEACH BOULEVARD: The boulevard was originally named Railroad Avenue, because the narrow-gauge railroad ran along the present location of the promenade. In 1896, the Metropolitan District Commission took control of Revere Beach. Charles Elliot ordered the removal of all buildings along the waterfront. Elliot wanted an uninterrupted view of the three-mile stretch of beach. Once the Metropolitan District Commission assumed control of Revere Beach, established building guidelines, and moved the train tracks to their current location of the MBTA Blue line tracks, the beach became a resort destination. Many restaurant and amusement entrepreneurs began building businesses to cater to visitors. *Inset*: Lounging on wet sand at Revere beach in the late 1920s.

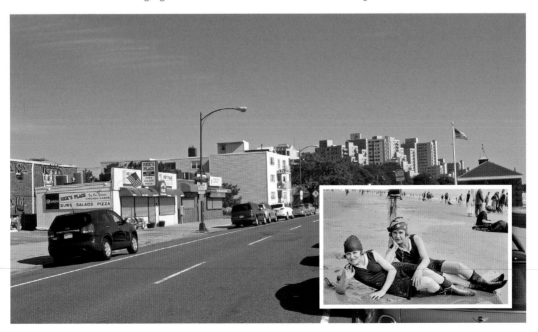

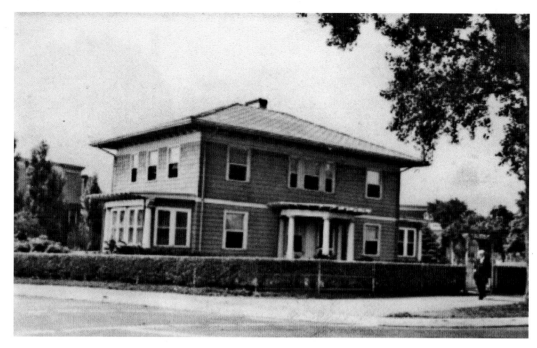

SUPERINTENDENT'S HOUSE: The above image is a view of the Superintendent's House, located at One Elliot Circle. The house was built in 1905 and was designed by William Austin. The home was originally designed to be a grand house with a stucco façade and roofed with molded ceramic tile. The home was inhabited from 1905 till the 1970s. It was designed in the Mediterranean style to compliment the other Metropolitan District Commission buildings along the beach. The below image shows the Superintendent's House as it looks currently. The home has undergone extensive renovations over the years and no longer has its side porches or its grand façade and tile shingles. In the mid-1970s, the home went unutilized and fell into disrepair. By the 1980s, however, the building was renovated and is currently used by the Department of Conservation and Recreation as office space for staff.

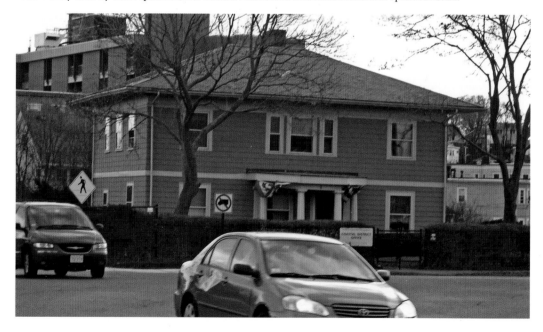

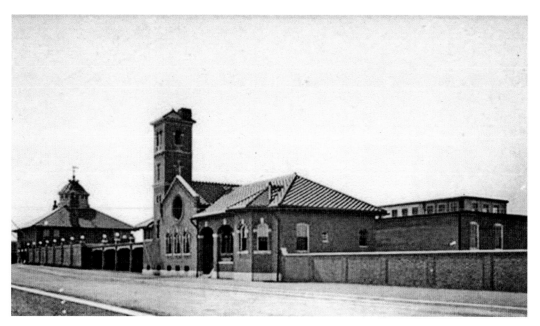

THE METROPOLITAN DISTRICT COMMISSION POLICE STATION: Located on Revere Beach Boulevard, the station was designed by William Austin and built in 1899. The tower is the most prominent feature of the station and features an observation deck. In 1980 the station was completely renovated inside. The MDC police inhabited the building until 1992 when they were merged with the Massachusetts State Police. The station looks out of place today since the Italian Renaissance style bath house that was located next to the station was torn down in 1962. During the 1980 renovations a six-foot copper cod fish weather vane was placed atop the tower. The codfish had originally graced the top of the original bath house and was thought to be lost forever until it was discovered in the attic of the police station. The Massachusetts State Police are currently utilizing the station.

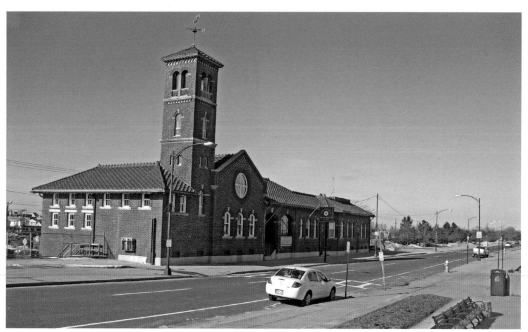

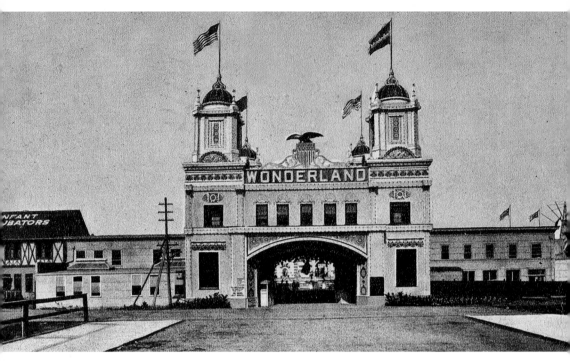

THE ENTRANCE TO WONDERLAND AMUSEMENT PARK ON WALNUT AVENUE: This was the grandest of the entrances and housed the management's offices. This entrance had thousands of electric lights to embellish the architectural marvel that was the park. The mere sight of this entrance evoked shock and awe among its visitors. Below is the view today. The grand entrance gate has been torn down and houses have been built along the fence line. There is still an entrance that allows pedestrians to access the strip mall that is partially built on the former amusement park site. *Inset*: A 1906 postcard published by James T Allen & Co., of Revere.

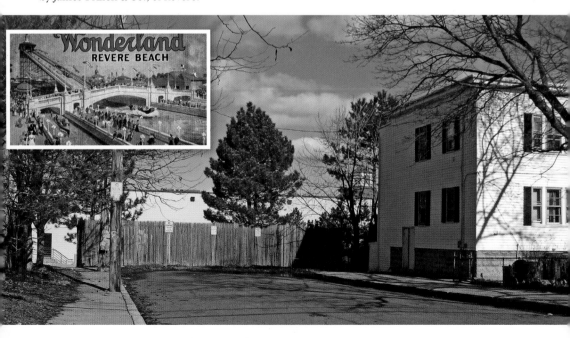

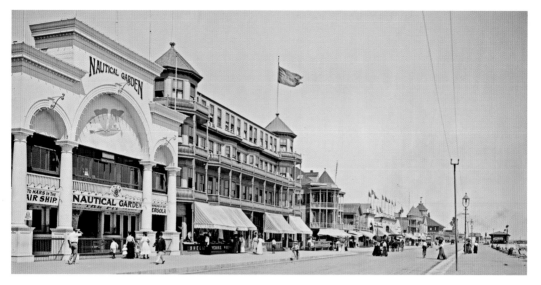

THE ENTRANCE TO THE NAUTICAL GARDENS ON REVERE BEACH: These amusements would never have been built if it were not for Wonderland. When opened on May 30, 1906, Wonderland was billed as New England's Premier amusement destination, it was America's first theme park. It was designed by Boston architect John Lavalle and built by Aldrich and Shea Construction Company at a cost of more than $1 million. The attractions featured the Nautical Garden, a Japanese Village, ballroom, working hospital, skating rink, and Pawnee Bills Wild West show and Fire and Flames, which set fire to a town twice daily and visitors could see Wonderland's own fire department in action. Even though 100,000 visitors passed through the gates, the park could not survive under its enormous overhead and closed forever on Labor Day in 1911. After, it was used as a bicycle track until 1934, when Massachusetts legislatures legalized pari-mutuel wagering. Wonderland Greyhound Park opened on the same site on June 12, 1935. The track even boasted of being able to operate year round due to a heating system that was under the track. In 2008, Massachusetts voters chose by referendum to abolish greyhound racing in 2010. The track hung on for a few months with just simulcasting betting and then closed its doors forever. *Inset*: A postcard of Wonderland Greyhound Park.

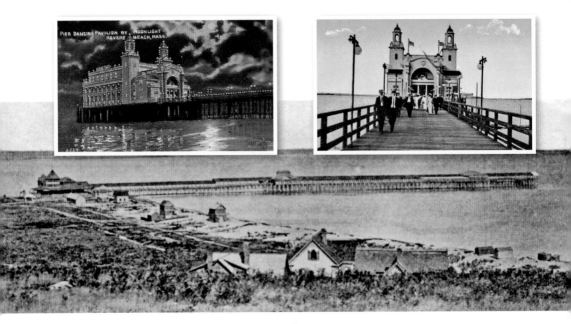

THE GREAT OCEAN PIER: The pier was built in 1881 by the Boston Pier and Steamboat Company, extending 1,700 feet into the Atlantic. The pier contained two large halls that housed a ballroom and a roller-skating rink with 500 seat café. In 1893 this impressive structure was dismantled and sold in sections. The area known as Roughans Point is now fully developed with year round homes and there is no longer steamship service to Revere from Boston or Lynn. Roughans Point was once referred to as little Charlestown due to the Charlestown residents who use to vacation in this area of Revere. This area was greatly damaged during the Blizzard of 1978. Today Massachusetts Water Resource Authority has spent millions on seawall improvements to protect this low lying area. *Insets:* The dancing pavilion and pier promenade by the main Revere pier which followed.

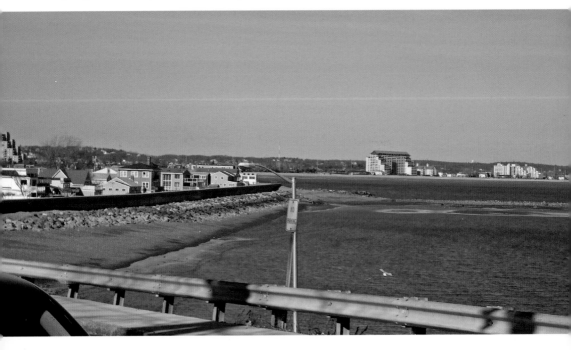

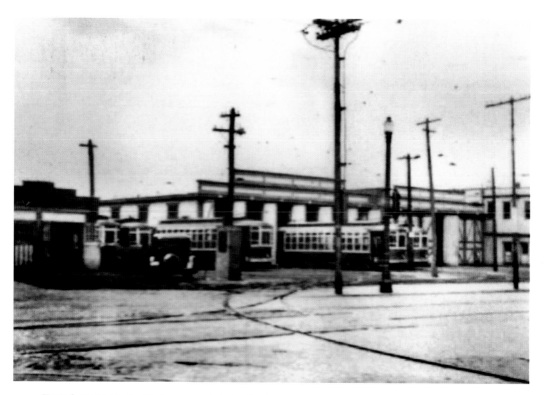

THE CAR BARN ON BROADWAY: Originally the Lynn and Boston horse car barn, this housed fresh horses to pull wooden trolley-like cars that ferried passengers between Boston and Lynn. When the Boston Elevated Railway Company began trolley service in Revere they rehabbed the old car barn on Broadway to house their trolleys. The car barn also housed repair facilities. The car barn remained on Broadway from 1885 till the late 1950s, when bus service replaced trolley service around the city. Currently on the site of the old car barn is the new Walgreens drug store, built in 2009.

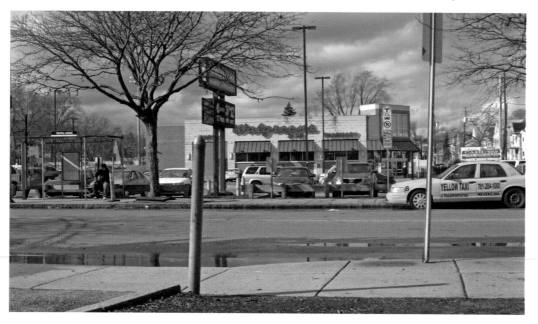

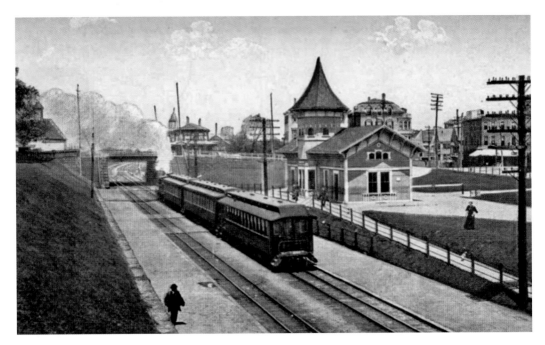

CRESCENT BEACH STATION: This was the gateway for thousands of visitors annually who made the journey to Revere Beach via the Boston, Revere Beach and Lynn railroad. Originally the trains were pulled by steam locomotives. By the mid-1920s the line was electrified and the steam locomotives were decommissioned. On January 27, 1940, the line ceased operation and sold the cars to rail lines around the country. The Crescent Beach Station was demolished sometime after the line ceased operating. When the Massachusetts Bay Transit Authority took over the line in the late 1940s a brick station was built to replace the original station that was razed. The new station was named Revere Beach Station. By the late 1990s Revere Beach Station had fallen into disrepair. The MTA rehabbed the station and gave it a very modern and clean look. This is the view of the Revere Beach Station as it looked in 2013.

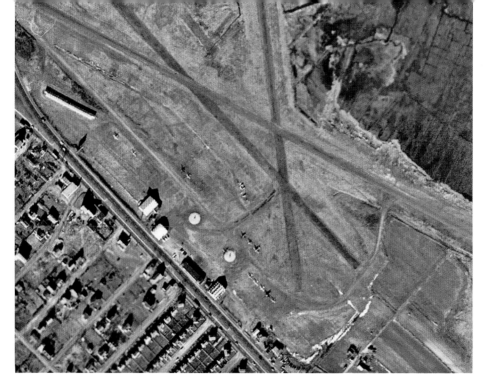

MULLER FIELD AIRPORT: This airfield operated on Squire Road and was in operation from the 1920s until 1962. The airfield was closed during World War II for security reasons. In 1946 Julius Goldman purchased the airport and opened Revere Airways. In 1947 the airport began seaplane and blimp operations, during which the Goodyear Blimp landed here. The airport was located were Northgate Shopping Center is today. This is the shopping center from above. Many people might remember shopping at Almy's, Zayres, First National Supermarket, Lerner, Thom Mcann, Kennedys and Top Scorer's Arcade. The shopping center was built in the mid-1960s after the airport was closed and the land sold off. The surrounding area was primarily tomato farms while the airport was in business. During the 1950s the tomato fields were converted to single housing lots.

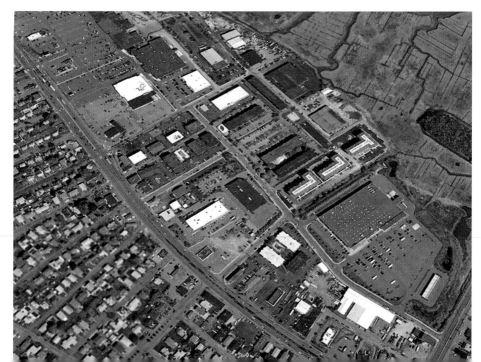

FENWAY NORTH: This motor lodge hotel was built next to Northgate Shopping Center to accommodate travels on Route 1. This was also an ideal location due to the proximity of Revere to Logan International Airport. Below is a view of the Sheraton Hotel in 2013, which was formerly the Fenway North Motor Lodge Hotel. The hotel has undergone extensive renovations since it was first built. Originally each section was only 3 stories tall, later on the hotel capacity was increased with the addition of more floors. When renovations were complete conference and banquet facilities were added as well as airport drop off and pick up service.

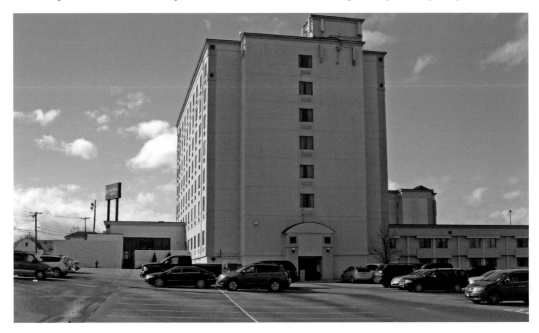

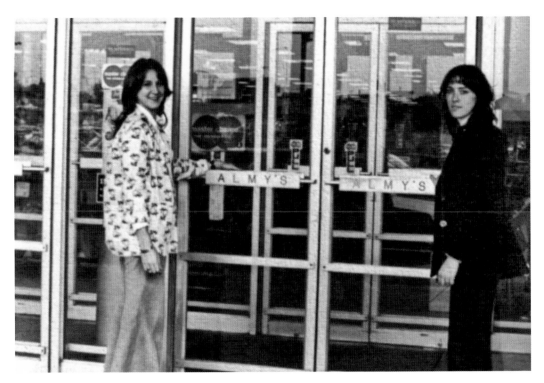

ALMY'S STORE: These two young ladies stand ready to assist anyone entering the Almy's store at Northgate Shopping Center. Almy's was the quintessential department store, with a candy counter, beauty shop, diner and a plethora of other departments. The store was in operation from the 1960s until 1987 when the Stop & Shop Company decided to shutter all 16 stores and cease operations forever. After Almy's closed the building was leased to Toys R'us. By 2011 the building was sitting vacant and awaiting a new tenant when a gas leak caused an explosion which severely damaged the building. The building was torn down and this was the site in 2013 during reconstruction.

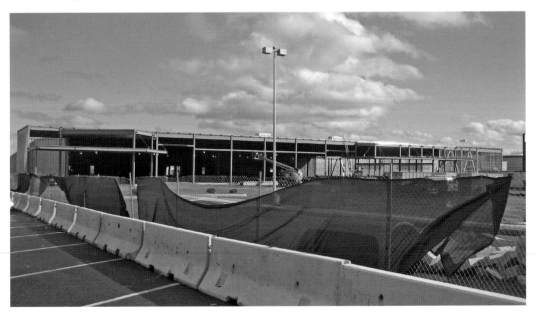

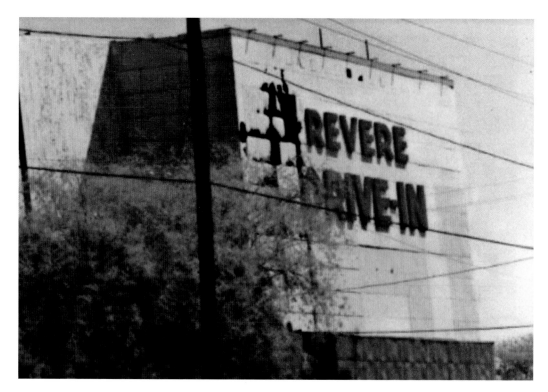

REVERE DRIVE-IN: The drive-In was in operation from the mid-1950s till the early 1980s. Many people may remember going to the drive-in with their family or on a date. The drive-in had one screen and a concession stand. The drive-in was built on marsh land. Below is a view of Showcase Cinemas built on the original site of the Revere Drive-In and of the first Showcase Cinemas building which operated on the site from the early 1980s until the early 2000s when the building was razed and a new state of the art deluxe theater was built on the site. There are currently 20 theaters housed in the building.

WHEELS PLUS ROLLER RINK: During the 1980s this was the hotspot to be if you were a teenager. You could skate all day for $3 and that price included the skate rental too. There was also a dance club located in the same building. Before the roller rink opened its doors the building was an ice hockey arena. After Wheels Plus Roller Rink closed its doors the building's interior was remodeled and was converted to a gym. Today the building is still in use as a fitness center. However for countless Revere residents it will always remain "Wheels Plus Roller Rink".

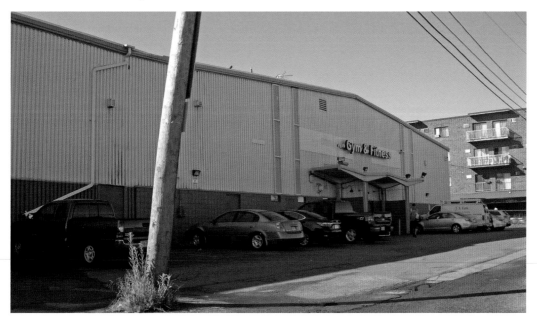

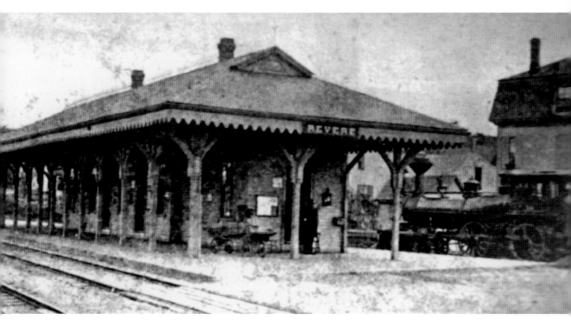

REVERE RAILROAD STATION: Originally the line was owned by Eastern Railroad. On August 26, 1871 there was a horrific train crash near the station in which 29 persons were killed and 57 injured. In 1884 the line was taken over by Boston and Maine. The last train stopped at the station on August 13, 1954, and made its final delivery of passengers and mail. The station was torn down a short time after passenger services ceased. At the time the station was constructed Winthrop Avenue was a grade crossing. By the 1940s a bridge was built to allow traffic to pass safely above and not impede the rail line. Below is the current view of where the railroad station once was stood.

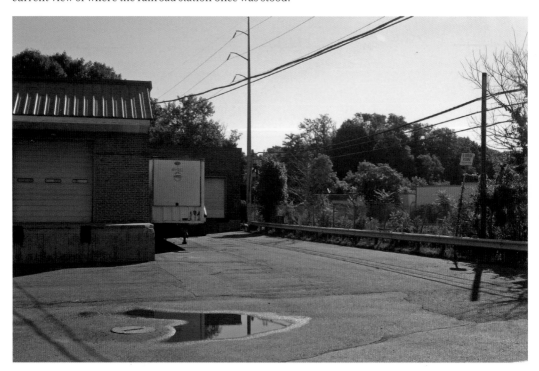

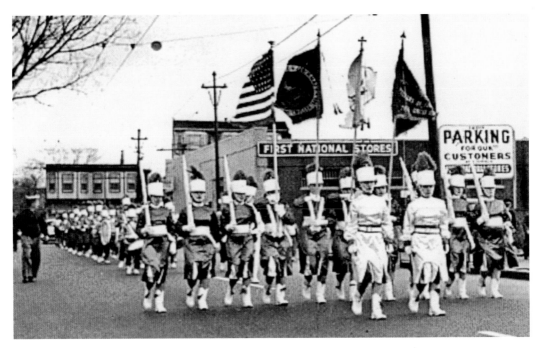

IMMACULATE CONCEPTION REVERIES DRUM AND BUGLE CORPS, MARCHING FROM BROADWAY TO PARK AVENUE: The Corps was established in 1957 by John Brown. Within five years the group was ranked among the top 10 corps on the East Coast. Below is the same view of Park Avenue looking towards Broadway, photographed 2013. Not much changed over the years. The First National Store has been replaced long ago with smaller stores occupying the former grocery store building.

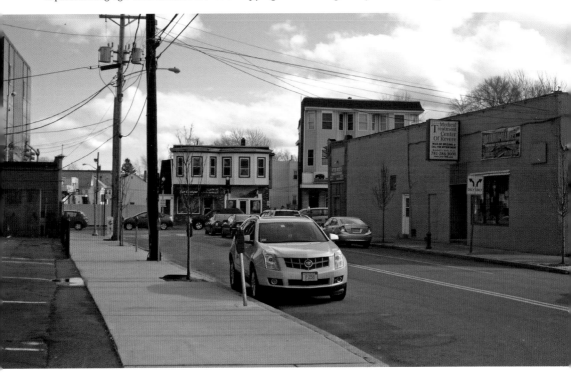

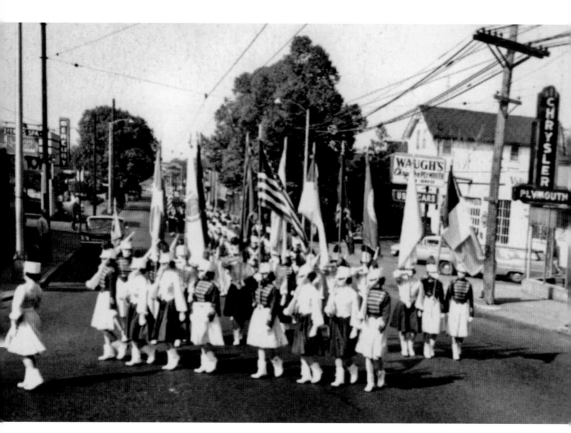

A Parade on Broadway, 1956: The group is about to turn on to Beach Street at Fennos Corner. Waugh's Chrysler and Plymouth dealership can be seen on the right of this photograph. Below is a view of Waugh's repair shop as it was in 2013, formerly Waugh's Chrysler and Plymouth dealership. A motorcycle dealership now occupies the former Waughs building.

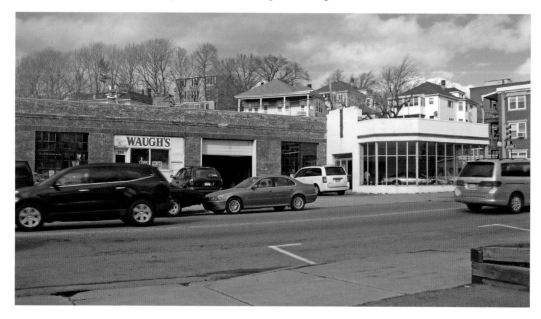

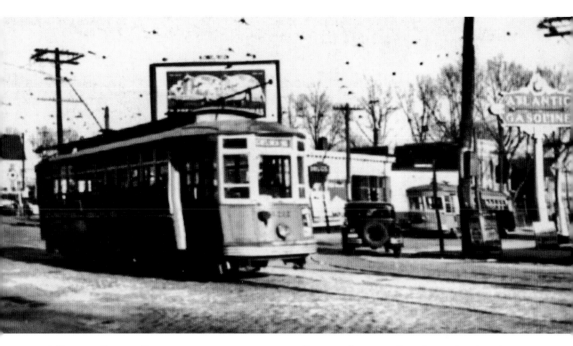

A STREET CAR ON BROADWAY AT THE CORNER OF REVERE STREET: The Atlantic Gasoline Station can be seen in the right of this photograph. To the left is the pharmacy. When this photo was taken automobiles just began to emerge as the predominant form of transportation. Below is the same view of Broadway and the corner of Revere Street in 2013. The street cars and tracks have long since been removed and replaced by bus routes. Although the gas station has changed names over the years it is still in business. The pharmacy across the street remained in business until the mid-1990s when they closed their doors forever.

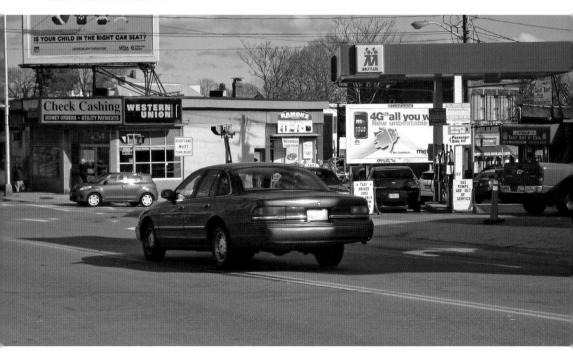

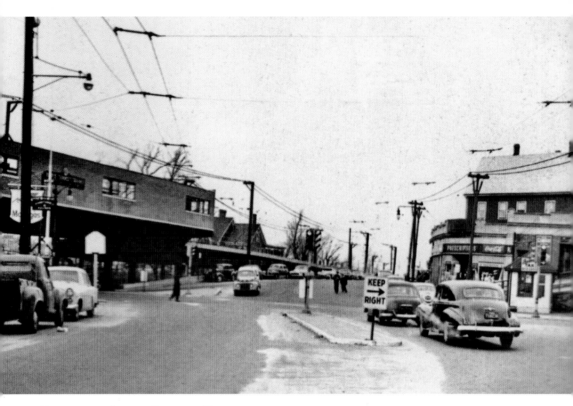

BEACHMONT SQUARE LOOKING NORTH: Originally the train station was a grade crossing. Once the Massachusetts Bay Transit Authority acquired the train line the immediately began by eliminating the grade crossing to allow traffic to pass unimpeded by the rail service. *Below* is a similar view of Beachmont Square as it was in 2013. The Beachmont train station has been remodeled. Dunkin Donuts currently occupies the former Mobil gas station site. Not much has changed over the years.

SALES CREEK FROM THE CORNER OF NORTH SHORE ROAD AND WINTHROP AVENUE: This is now Revere Beach Parkway. In the late 1960s the creek was allowed to be filled in as pumping stations had been established to prevent flooding. The Cerretani supermarket building has been razed and apartment buildings will occupy the site.

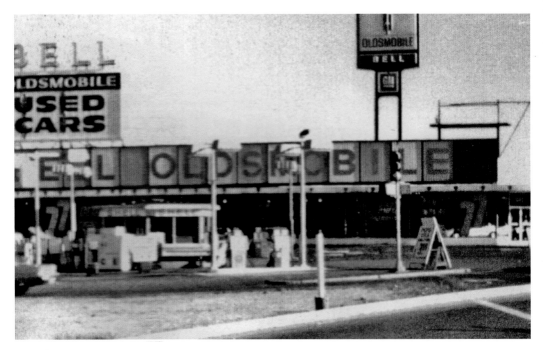

BELL OLDSMOBILE: This dealership operated at Bell Circle from the 1940s until the late 1970s. This is a view of the Bell Oldsmobile dealership during the 1970s. A gas station was located prominently in the front of the dealership parking lot. Below, a current view of the former Bell Oldsmobile dealership site. After the dealership closed down auto repair shops rented the former service area garages. Lappen's Automotive Parts occupied the former showroom and the gas station closed down. In the early 2000s the old dealership building was completely torn down and replaced with a modern strip mall.

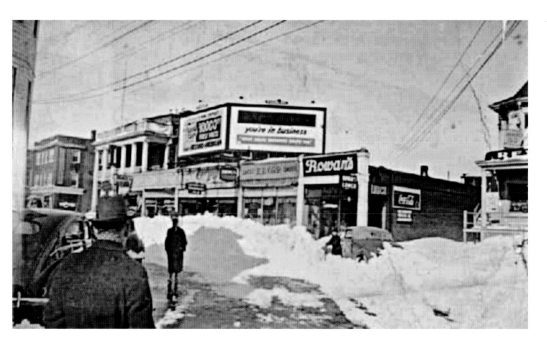

SHIRLEY AVENUE LOOKING WEST FROM ORR SQUARE: Rowan's luncheonette can be seen on the right along with a portion of the Veterans of Foreign Wars building. This photograph was taken after an extremely large snowfall as evident by the massive snow banks. Below is a view taken in 2013 of Shirley Avenue looking west from Orr Square. Rowan's luncheonette has been replaced by a liquor store and the VFW building has since been torn down. The second floor porch on the Elks Club building has since been torn down.

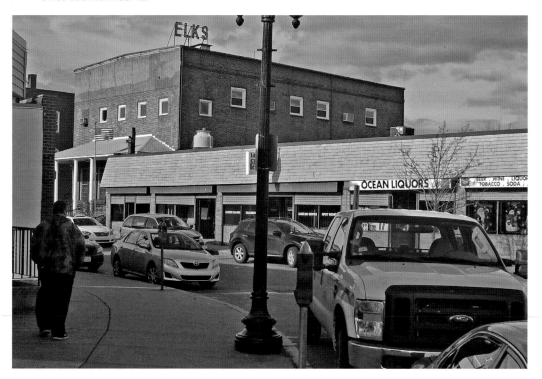

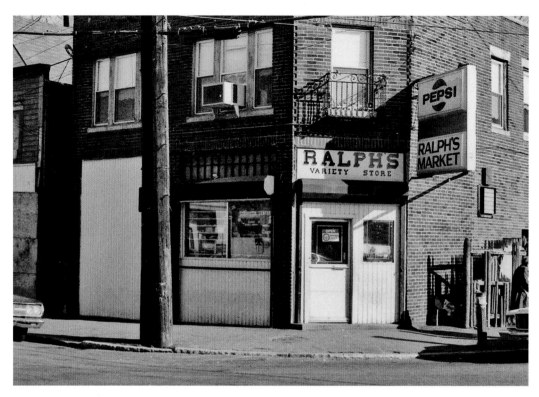

RALPH'S MARKET: A photograph taken sometime during the 1980s. This neighborhood store was located on North Shore Road across from the Gulf Service Station which was operated by Mr. Folsom. Below, the same view as photographed in 2013. Paula's occupies the site of the former Ralph's Market. The Gulf Service Station across the street has since been torn down and replaced with a three story building which houses Atlas Auto Body.

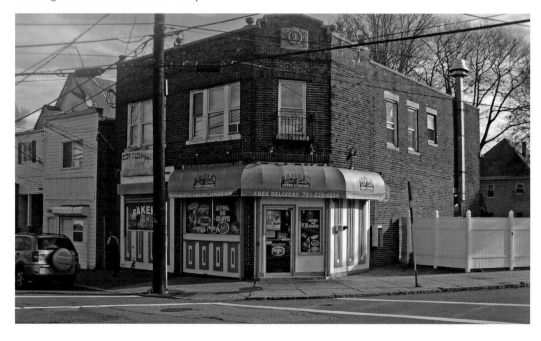

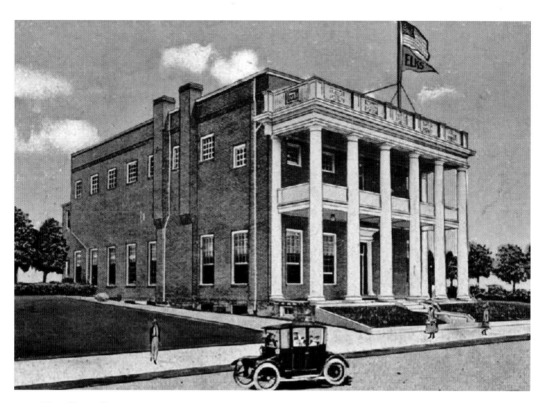

THE ELKS CLUB: This was first built on Shirley Avenue at the turn of the twentieth century. Notice the double story porch on the front of the Elks building. The porch was removed sometime during the 1960s. Below is a view of the Elks Club building as it looked in 2013. Except for the removal of the double porch, this building has not changed much over the years. Shirley Avenue has become more crowded since the Elks building first opened.

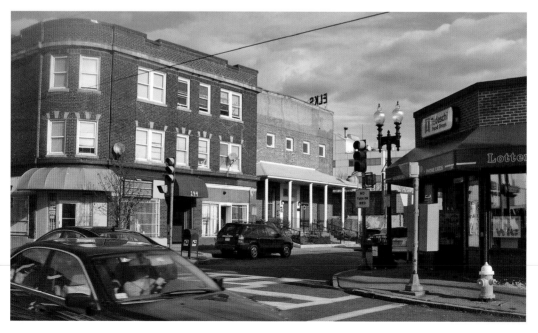

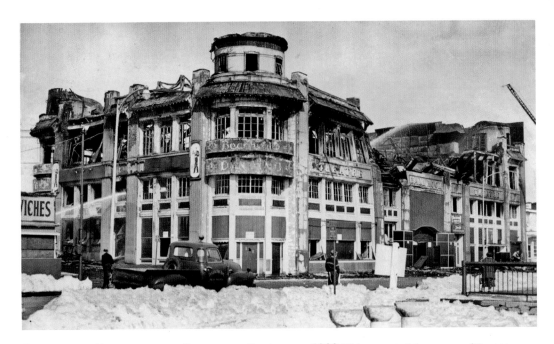

FIREFIGHTERS DAMPENING THE FIRE AT THE BEACHVIEW, 1960: This occupied the corner of Revere Beach Boulevard and Shirley Avenue. This was built in 1913 as the Crescent Gardens Ballroom and slightly later it also housed a movie theater. A horrendous fire consumed the building in 1960, the last ballroom on the beach. Below is a view of the former site of the Ballroom. Prior to the fire the ballroom had undergone a succession of name changes before settling on the Beachview. It was torn down after being irreparably damaged by the fire. Today the site is utilized as a park as part of the Revere Beach Reservation. *Inset*: the Ballroom in its former splendor.

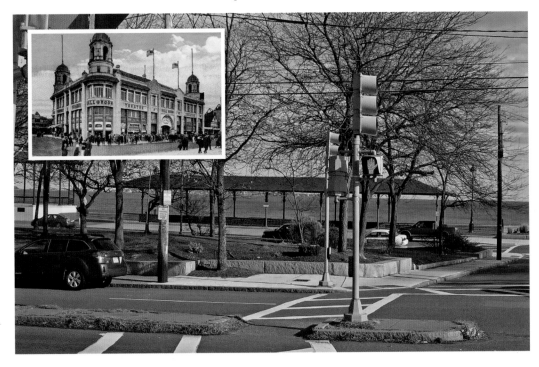

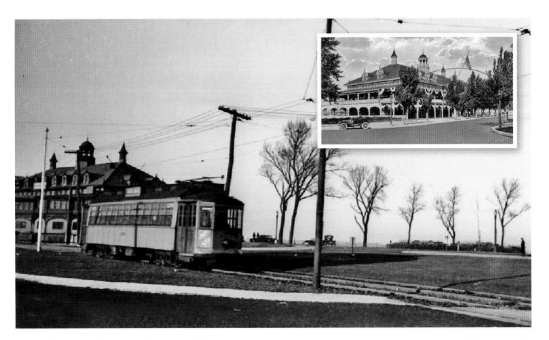

CONDIT'S SUMMER DANCING PAVILION: The Pavilion opened on June 17, 1904. The ballroom cost J. Condit $20,000 to build. It was purchased by the Ridgeway family after Condit's death and the name was changed to Spanish Gables. Sometime during the 1940s the name was changed again, this time to The Oceanview. The building was completely destroyed by fire in 1959 and claimed the life of Revere firefighter Melvin Caissie. *Inset:* Condit's Pavilion *c.* 1910, a postcard view. *Below:* The Atlantic Towers Apartments currently occupies the former site of the Oceanview Ballroom. The apartment complex was built sometime during the 1960s and set the tone for future high rise residential development along the beach. *Inset:* A postcard view of Condit's Pavilion (left), and the Boulevard (right) to show their relevant positions on Revere Beach.

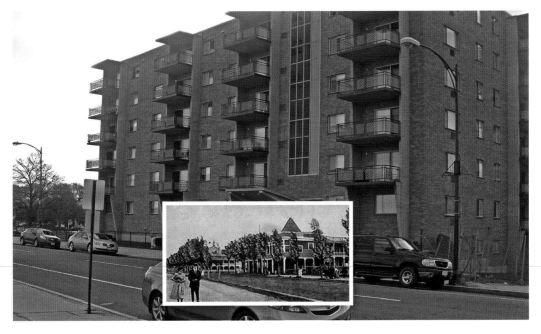

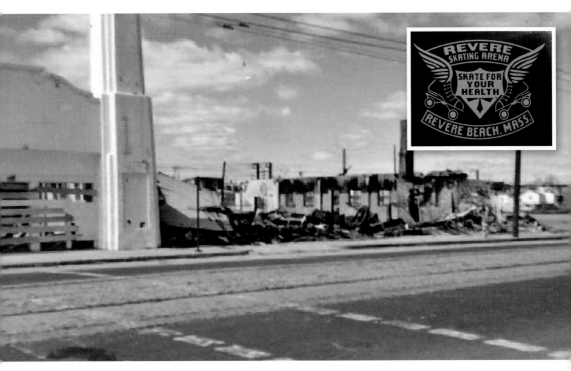

THE ROLLER SKATING ARENA BEING TORN DOWN: The Arena was located at 658 Ocean Avenue. The two rinks operated from the 1930s until the mid-1970s. The Arena would host skating contests as well as dance marathons. *Below:* The current view of the site of the former Roller Skating Arena. After closure the site was utilized as a parking lot and equipment storage facility before being developed into luxury apartments. *Inset:* A Revere Skating Arena decal.

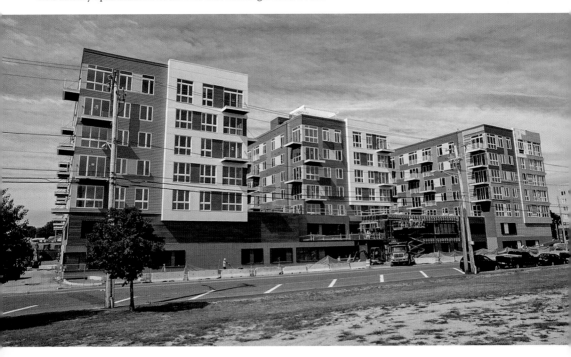

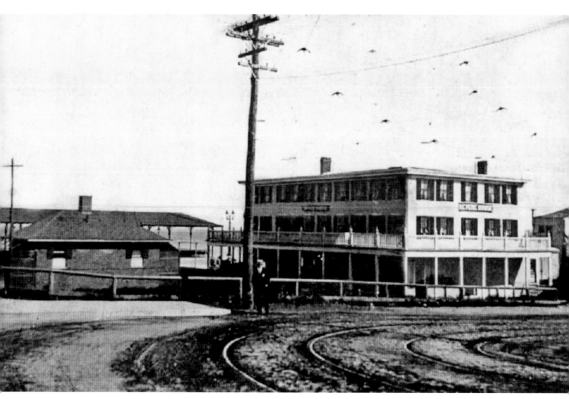

THE REVERE HOUSE: The hotel was located at the foot of Revere Street and Ocean Avenue and was typical of the several small hotels which operated during the early years along Revere Beach. The hotel operated above a restaurant that served patrons who stayed at the hotel or came in from the beach. This photograph is of the back of the hotel from Ocean Avenue. *Below:* The current view of the site of the former hotel. After closure the building was torn down and the Ebb Tide Lounge later occupied the site. By the 1970s the Ebb Tide had changed its name to the Beach Ball and Aerosmith even played here. After the blizzard of 1978 the buildings on this site were severely damaged and were torn down. In the 1980s the site was converted to a park.

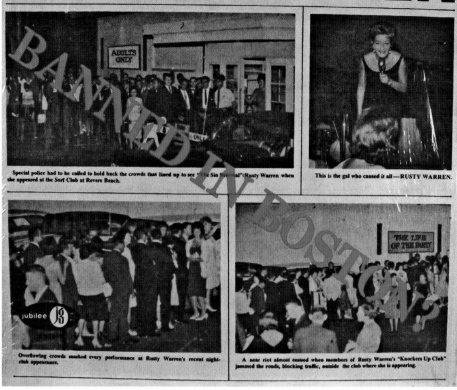

RUSTY WARREN

Special police had to be called to hold back the crowds that lined up to see "The Sin Sational" Rusty Warren when she appeared at the Surf Club at Revere Beach.

This is the gal who caused it all—RUSTY WARREN.

Overflowing crowds marked every performance at Rusty Warren's recent night-club appearance.

A near riot almost ensued when members of Rusty Warren's "Knockers Up Club" jammed the roads, blocking traffic, outside the club where she is appearing.

THE SURF CLUB AT REVERE BEACH: This is the cover of Rusty Warren's live album "Banned in Boston" which has photos of crowds waiting to gain entrance to the Surf Club at Revere Beach on Ocean Avenue. The Surf Club originally opened as a nightclub with live entertainment. By the 1970s the club had transformed to an adult entertainment club and eventually closed its doors permanently in the 1980s. The buildings sat vacant until 2000, when they were finally bulldozed. The site was then developed and an apartment complex was built on the site.

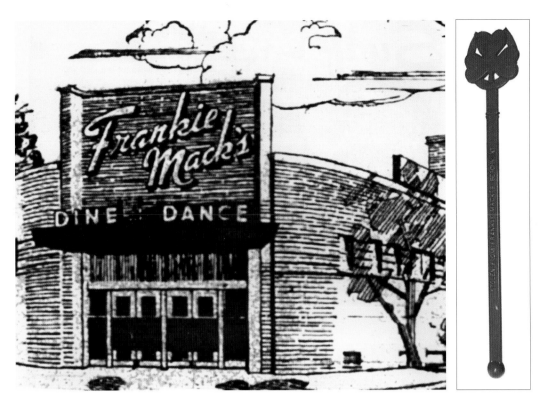

FRANKIE MACK'S DINE & DANCE: Frankie Mack's was a supper club in the heart of Beachmont Square. This club was well known for its affordable prices and quality floor shows. The restaurant operated from the 1950s until the mid-1970s when it closed its doors forever. The building was renovated and utilized as a Boys and Girls Club and then as the Revere Family YMCA. The building was torn down in 2012. This is a view of the site today, converted into a small park. The green swizzle stick to the right, from the 1970s, was from Frankie Mack's supper club, offered on eBay recently.

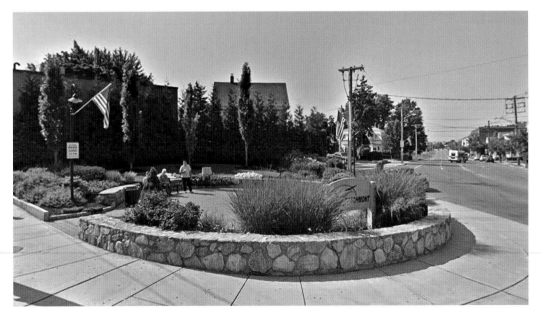

DIMINOS SUBS: The building was originally a home that was converted to a gas station. Sometime during the 1960s the gas station was closed and the first floor of the building was converted to a sub shop. The top floors were rented out as apartments. The original Diminos Subs building was torn down in 2005. The current Diminos Subs building was built behind the original building. Today the original site serves as a parking lot for Diminos Subs, and other businesses.

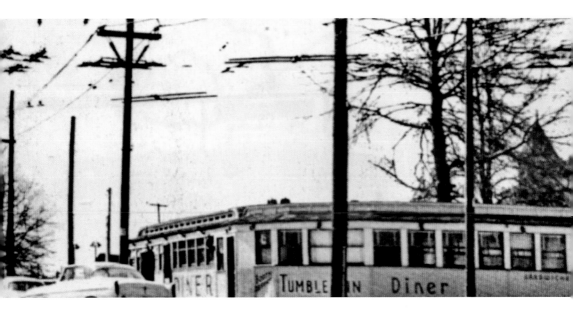

THE TUMBLE INN DINER: The diner was located on the corner of Beach Street and Ocean Avenue. It was a landmark in Revere and operated on the site until the early 1970s. *Below:* The view of an office building located at 300 Ocean Avenue, photographed in 2013. The building currently occupies the site of the former diner. Erected on the site in the mid-1980s, it is currently home to the Massachusetts General Hospital clinic on Revere Beach. There are also other businesses occupying the building with MGH.

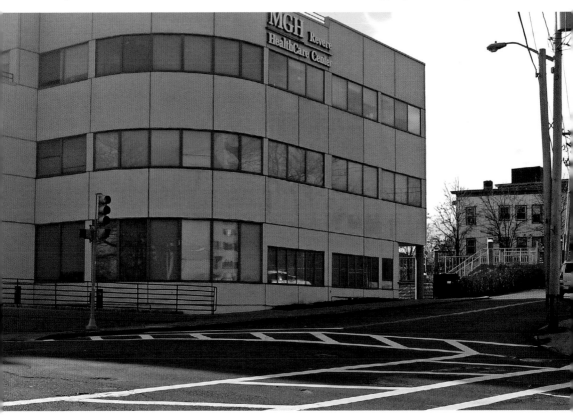

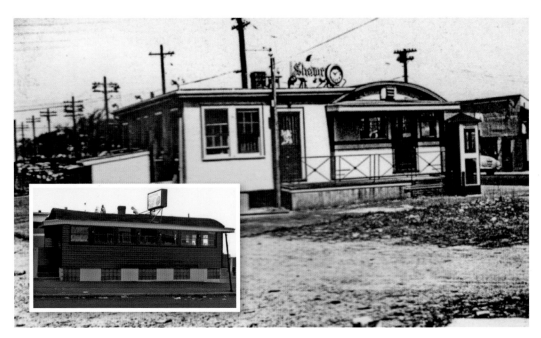

THE SHAMROCK DINER: This diner, in Worcester Lunch Car No. 811, was a favorite among local residents. The Shamrock Diner was delivered on June 15th, 1948 and is the first Worcester with the new flat overhangs over the end walls. It was located on the corner of Washburn Avenue and Winthrop Avenue next to the Beachmont train station. This view is the rear of the dining car with additions. The diner was in business until the mid-1960s. *Inset:* Front view of Beachmont Roast Beef when you could still see the "diner", presumably not long after taking over from "The Shamrock". *Below:* This is a rear view of Beachmont Roast Beef, photographed in 2013; the same lunch car that the Shamrock Diner once called home. The exterior of the car has been renovated as has a portion of the interior. The stools at the counter have been removed and the interior has been updated.

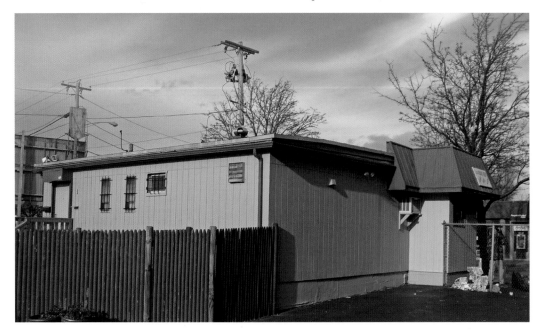

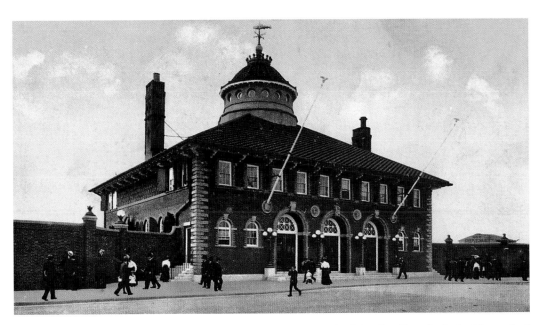

THE STATE BATHHOUSE: The original State Bathhouse was built in 1897. By 1962 the bathhouse had been slated for demolition. The original bathhouse had laundry and repair facilities for the rented bathing suits. In 1963 a new modern State Bathhouse was built on the same site. *Below:* This photograph of 2013 shows the site of the former State Bathhouse. The second bathhouse was razed in 1988. The site was used by the state and the State Police as a parking lot and storage lot for snow plows. Currently the site has been converted to a park and pedestrian foot bridge. The footbridge was constructed in 2012, as part of the Wonderland development project.

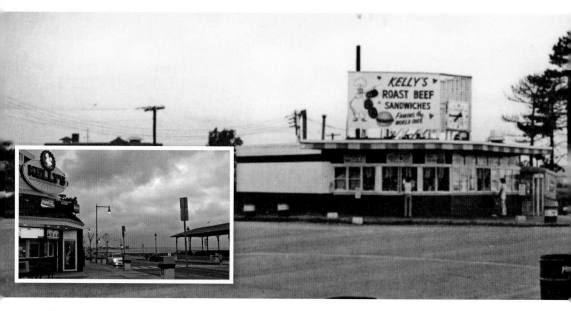

KELLY'S ROAST BEEF: Now a chain and an institution, Kelly's was started by two friends, Raymond E. Carey a former restaurant manager and Chef Frank V. McCarthy. They opened their takeout business in a building located on the corner of Oak Island Street and Revere Beach Boulevard. The building has undergone updates to its exterior and the menu signs. This restaurant has become a landmark on the beach. Kelly's is also the only remaining business that has lasted on the beach since the amusement park was present and active. *Inset:* An early evening view looking along the seafront.

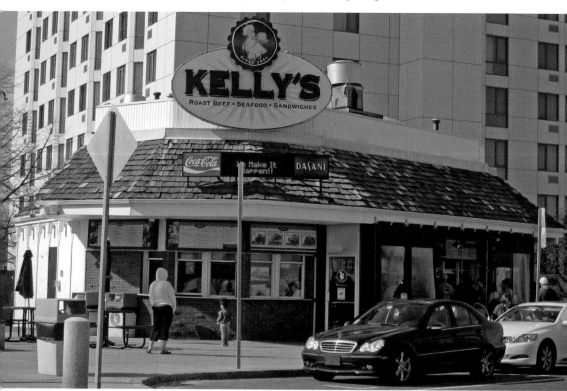

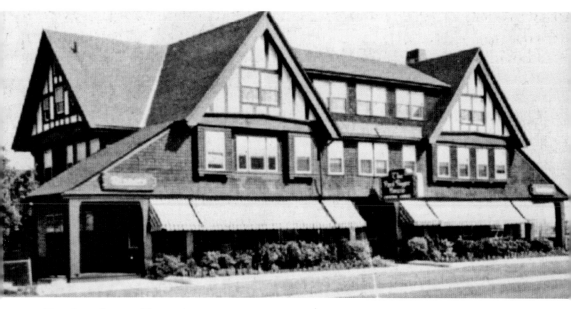

THE PAUL ROGER HOUSE: The house was located near the corner of Oak Island Street and Revere Beach Boulevard. The restaurant and cocktail lounge, inn and function facility was owned and operated by the Carey family. Originally the Tudor style building was built by the Episcopalian Church and was known as Mothers Rest. This building was used as a retreat for woman and children from numerous parishes. The Paul Roger House closed its doors and the building was torn down sometime in the 1970s. The Jack Sater House currently occupies the site. It was built in the early 1980s, as a housing complex for the elderly. *Inset:* A color postcard from the 1960s.

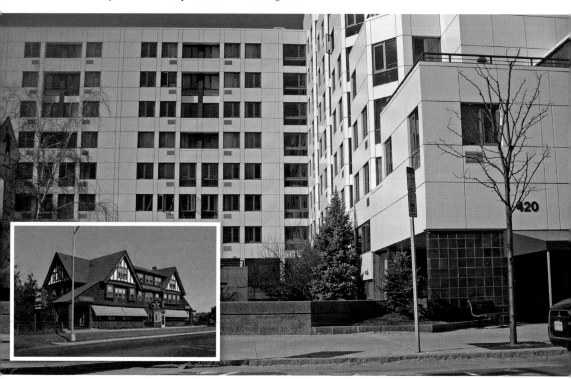

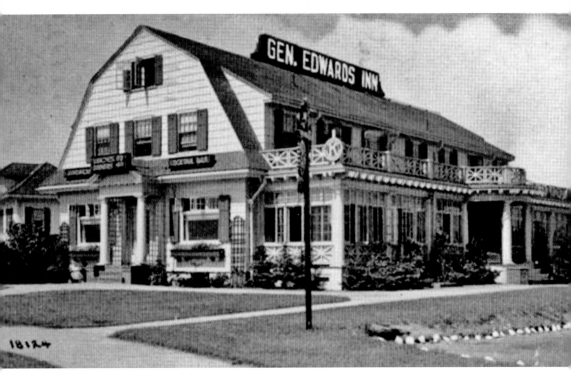

THE GENERAL EDWARDS INN: The inn was owned and operated by the Carey family. This modest restaurant catered to families seeking good food at an economical price. They had a lounge in the basement, on the first floor was the restaurant and function facility, upstairs were rooms that were available for rent. The General Edwards Inn closed its doors and ceased operations in the 1980s. *Below:* After the General Edwards Inn was closed the building and land were sold. In the 1990s the former restaurant building was torn down. This apartment complex, photographed in 2013, was built on the former site and today is one of the most desirable locations to reside in the city of Revere.

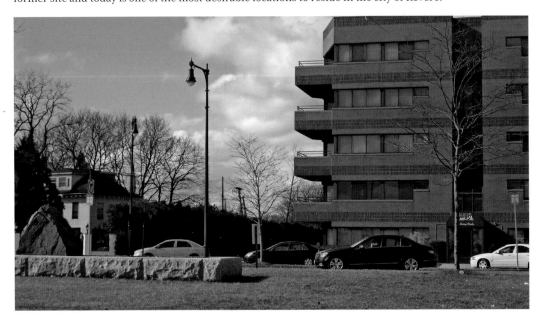

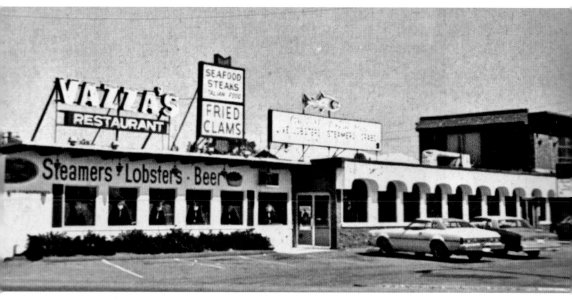

VAZZA'S RESTAURANT: The restaurant was located at Broadway Circle and Squire Road. Ralph "Chubby" Vazza operated and owned this restaurant until sometime in the 1980s. The restaurant served fresh seafood and had a lounge as well. *Below:* This is a current view of the former Vazza's Restaurant site. The restaurant was torn down and this Sunoco gas station now occupies the site. The service station was built in the 1990s. *Inset:* Chubby's brother, Vincent (1922-1958), was part of the seamier side of Revere life. He was an ex-boxer in the Boston underworld who came to a bad end. According to the wire story of his passing, Vincent Vazza, a Revere resident, was "reputedly a muscleman for a loan shark ring." After a night at the Rockingham track, he went "missing from his usual haunts" and soon his new Dodge was spotted in East Boston. His brother Chubby noticed that the car "seemed to sag in the rear" and you can guess what was in the trunk—the beaten, strangled body of Vincent. No arrests were made. *Boston Herald*

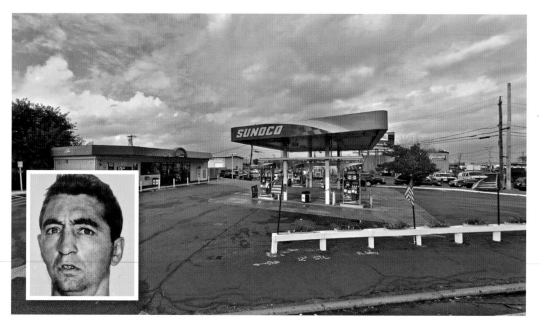

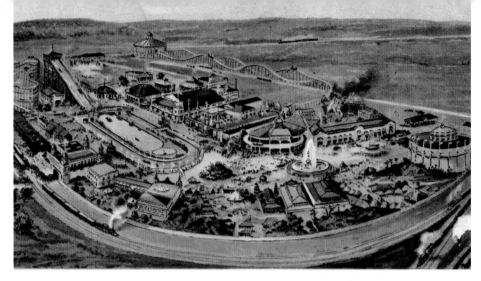

WONDERLAND 1907: A color postcard of Wonderland in 1907. The amusement park was built on 25.9 acres of land. Because of the success of Revere Beach Boulevard, three men worked together to create Wonderland. John J. Higgins, a commercial real estate broker and Floyd C. Thompson, a visionary with interest in amusements parks, combined their talents with those of another important figure in Wonderland's history; Major Thomas D. Barroll. Major Barroll had a very distinguished military career and had many skills as an entrepreneur. The centerpiece of Wonderland Park was a beautiful lagoon and part of an elaborate and exciting ride. The ride was called Shoot the Chute. Passengers would be lifted in their gondolas to the top of a steep grade. Once at the top, the gondola would be dropped down the water slide and back down into the huge lagoon. Like Disney's theme parks, parades occurred daily. There were international cultural exhibits, demonstrations, educational displays and also scientific exhibits such as the infant incubators at the park's full service hospital. Because of their aggressive approach to out-do previous exhibits and the unpredictable New England weather, its operators suffered great financial difficulty and had to close down in 1911. *Below:* Close to Wonderland was the Derby Racer. This was the name of a wooden roller coaster that operated at Revere Beach close to the Cyclone. The first coaster was built in 1911 and demolished in 1936.

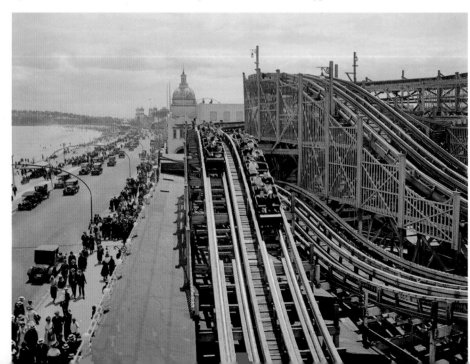

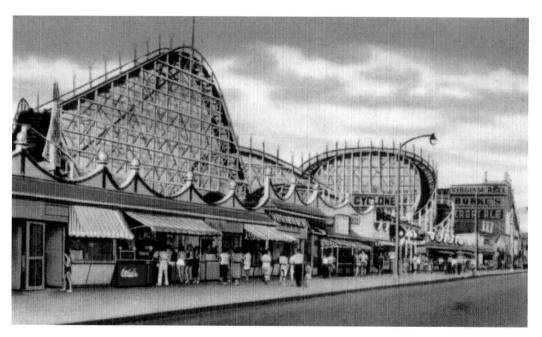

THE CYCLONE: This was a wooden roller coaster that operated at Revere Beach. When constructed, it was the tallest roller coaster ever built, as well as being the first in the world to reach 100 feet in height. In addition to being the tallest of its day, some also claim that it was the largest and fastest roller coaster in the world with top speeds up to 50 mph. The above image is from a 1950s color postcard. *Below:* The Shayeb family built the Cyclone in 1924. The coaster ceased operations in 1969 due to rising insurance and maintenance coasts. It was completely destroyed by fire in 1973 and torn down by 1975. This 2013 photograph shows the land that the coaster utilized being is part of the greenway of the Revere Beach Reservation. *Inset:* Joan Gutmann in 1934 posing for a picture on Revere Beach with the Cyclone in the background. Notice the wooden pavilion in the background. These were sporadically located along the boulevard and offered shade for bathers.

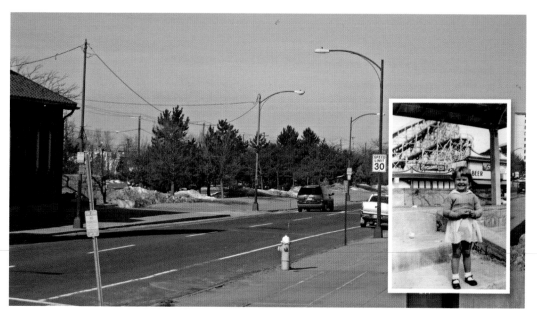

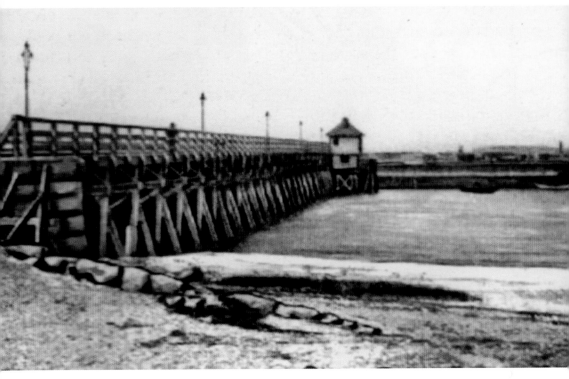

POINT OF PINES BRIDGE: This is the original bridge that connected the Point of Pines to Lynn. It was built in 1906 and was utilized as a direct route to the North Shore. The bridge caught fire in 1921 and was rebuilt in 13 days. *Below:* The General Edwards Inn Bridge was built in 1933 and has been in constant use since its construction. Except for yearly maintenance and general upkeep the bridge has not been altered or modified since it was constructed.

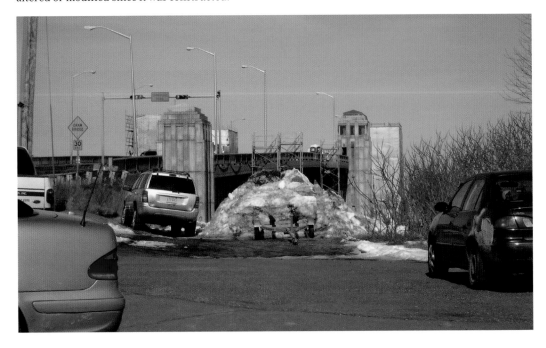

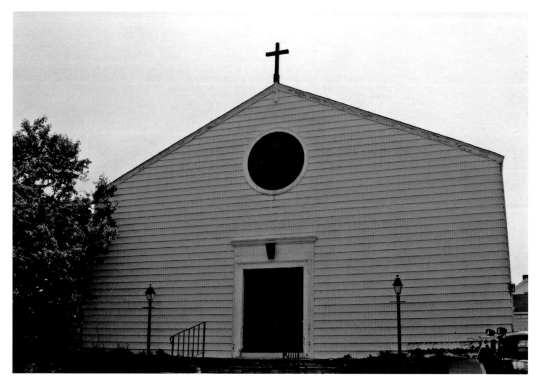

SAINT JOHN VIANNEY CATHOLIC CHURCH: This church was located at the corner of Harrington Avenue and Revere Beach Boulevard. It opened its doors to parishioners on October 28, 1951 and contained a hall in the basement, an auditorium and a large choir loft. The Boston Archdiocese closed the parish in 2004 and the church was sold. *Below:* This is a 2013 view of the church. The building was cut in half and the middle was torn down. The remaining structure halves were converted into two separate single family homes in 2006.

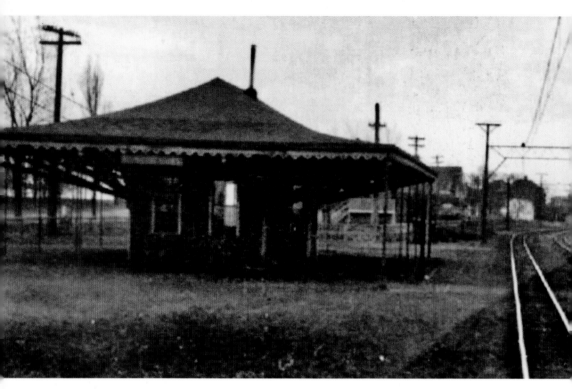

THE POINT OF PINES RAILROAD STATION: This was the last stop in Revere for the narrow gauge line. It ceased operation in 1940 and this station was closed and later torn down. The station was not needed when the MBTA took over the line since service would now terminate at Wonderland. *Below:* This is the Point of Pines Fire Station photographed in 2013. The station was built in 1938, near the site of the Point of Pines station. The fire station is currently closed and utilized by the Revere Fire Department for training purposes.

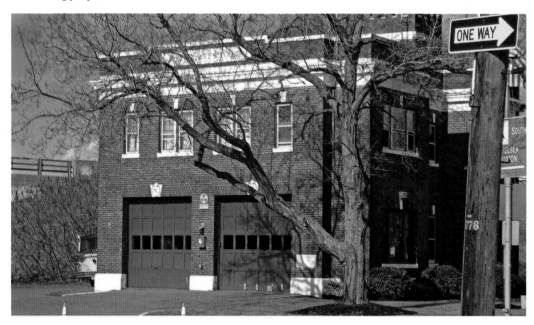

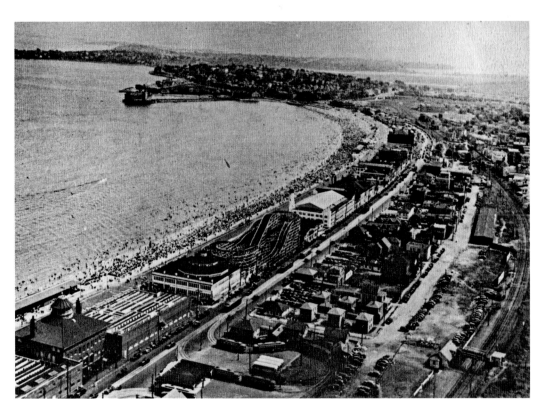

REVERE BEACH FROM THE AIR: This is a panoramic view of the beach looking south *c.* 1935. The beach was crowded with amusements and restaurants. Notice the neighborhood houses between Ocean Avenue and the railroad tracks. Also the aerial view of the original State Bathhouse shows the enormity of the complex to accommodate the many bathers. *Below:* This is a current view of the beach as it looks today. Notice the six high rise buildings along Ocean Avenue were built on the sight of the homes along Baker Avenue.

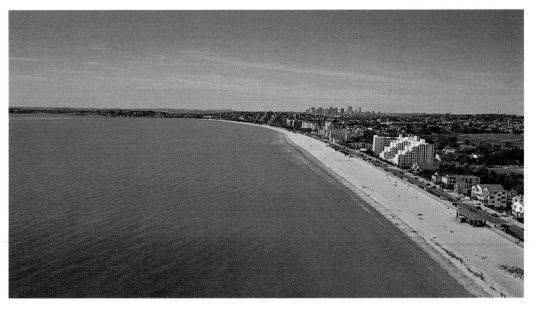

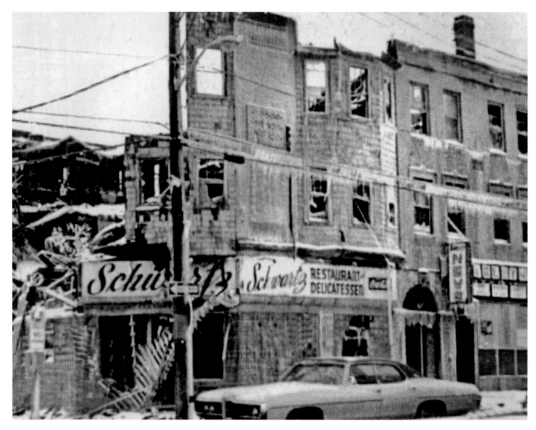

SCHWARTZ DELICATESSEN: Schwartz was a landmark located on the corner of Shirley Avenue and North Shore Road. This restaurant was well known throughout the city for its corned beef sandwiches. No matter what time of day this place was always crowded with loyal customers. The building was completely destroyed by fire in the 1970s. *Below:* After the fire the building was torn down and never replaced. The debris from the structure was hauled away and the site was purchased by the bank across the street. Currently the former site is being utilized as a parking lot for the bank.

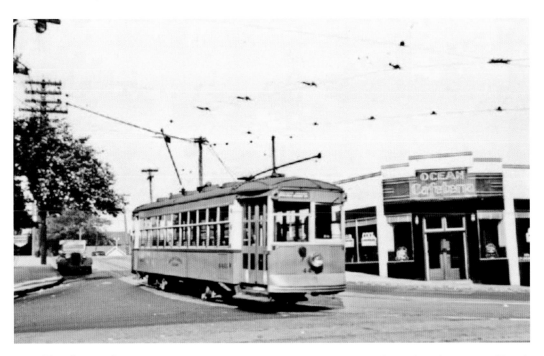

THE OCEAN CAFETERIA: During the 1930s the Ocean Cafeteria was located on the corner of Beach Street and Ocean Avenue. It is unknown as to exactly when it closed its doors and ceased operations. *Below:* This is a 2013 view of the Banana Boat which occupies the site of the former Ocean Cafeteria. The Banana Boat has been in operation since the 1970s and has continually offered frozen treats to beach goers every summer.

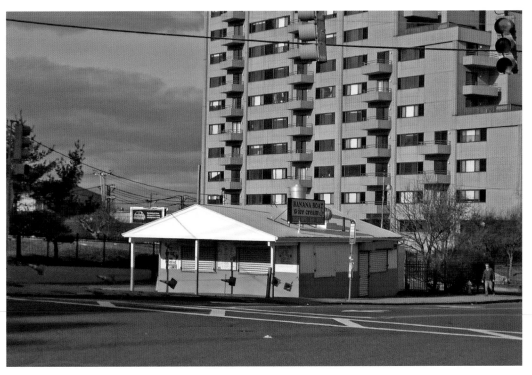

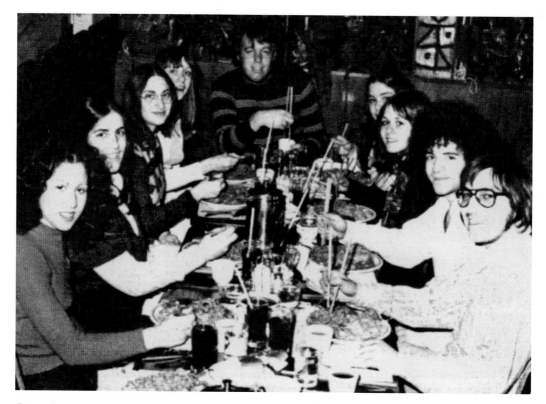

CHINA LANTERN: During the 1960s China Lantern was in operation along Ocean Avenue. The restaurant was owned and operated by the DiCarlo family. Here we see a group of patrons enjoying a meal at the China Lantern restaurant. This restaurant and lounge were a popular nightspot in Revere. *Below:* The building that housed China Lantern. The restaurant closed its doors in the 1980s and another Asian cuisine restaurant opened in its location. After lasting a couple of years they too went out of business.

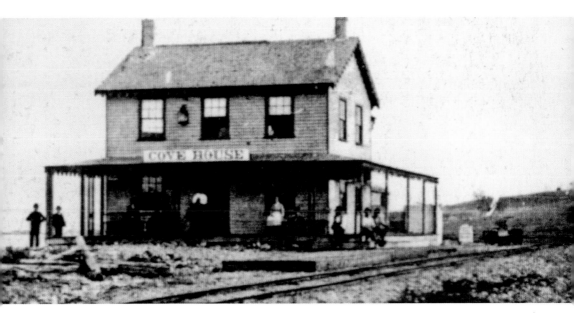

THE COVE HOUSE: This house was built in 1868. Notice the railroad tracks and Beachmont hill in the distance. This building was one of the first businesses on Revere Beach. It was completely destroyed by fire in 1881 and never rebuilt. *Below:* This is the location of the Cove House at Elliot Circle, photographed in 2013. Once the Metropolitan District Commission took control of the beach the railroad tracks were removed and placed further away from the beach. The site is currently a major traffic intersection.

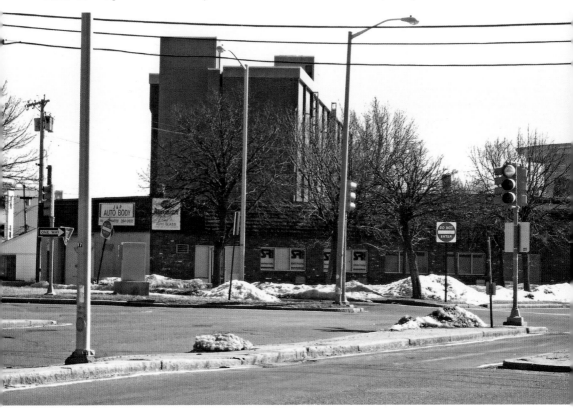

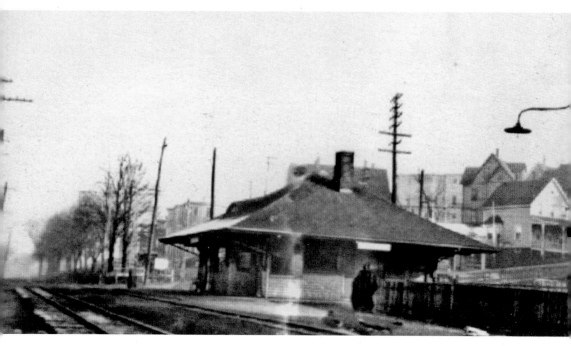

BEACHMONT STATION: This is a view of Beachmont Station from Washburn Avenue. The station was originally a grade crossing. In this picture we can see how Beachmont was not densely populated during the time the photograph was taken. *Below:* A current view of Beachmont Station. The station is at street level and the tracks were elevated in the late 1940s. The MBTA completely renovated Beachmont Station in recent years. This station is completely modern and handicap- accessible which is a far cry from the original narrow gauge station.

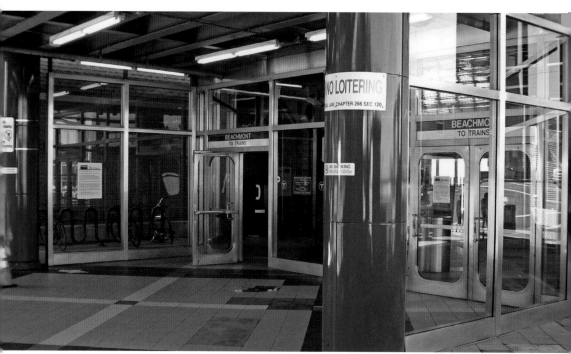

THE BEACH CLOCK: The Metropolitan District Commission had a large clock placed on the sidewalk across from the bathhouse. The clock faced the beach and was erected to keep patrons of the bathhouse informed of the time so that they could return their rented bathing suits on time. Lifelong Revere resident Ernest Egleston battled with the MDC for over twenty years in an attempt to have the clock face motorists and pedestrians on the boulevard to no avail. The clock was taken down during renovations to the beach. Some people believed the clock was buried under the new bathhouse when it was built, however this has never been proven. A new clock was erected on the same site as the original clock in the 1990s.

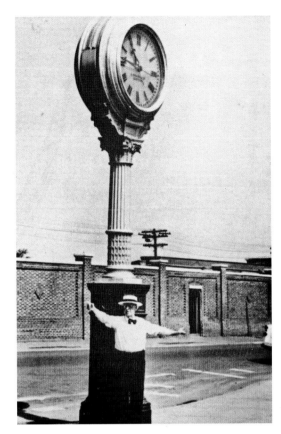

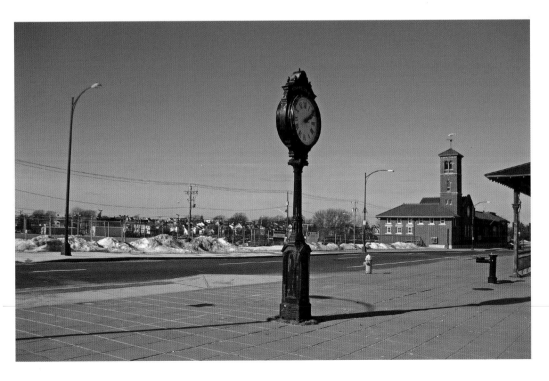

LUIGI'S—THE ITALIAN EATERY: A view of the stores on Winthrop Avenue across from the Beachmont Train Station taken during the 1970s. A portion of the original T station can be seen in the upper right hand corner. *Below:* A current view of the stores on Winthrop Avenue. The property has been renovated and is occupied by Luigi's Italian Eatery and Patriot Taxi. Luigi's has been in business since the 1980s and has become a beloved landmark in the community. In this photo a train happens to be in at the station.

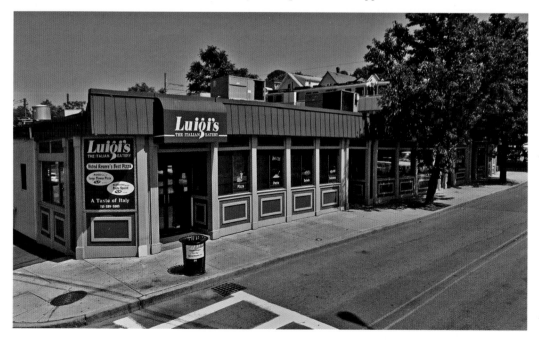

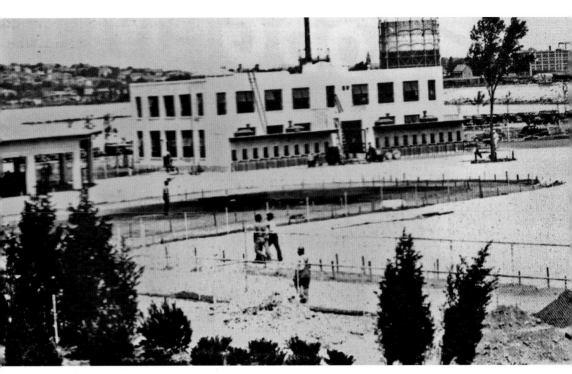

SUFFOLK DOWNS: In 1935 Suffolk Downs Racetrack was built. This track was the largest in New England. Here is a view of the paddock area and administration building under construction. Suffolk Downs has hosted the famous race horse Seabiscuit and the Beatles performed here in the 1960s. *Below:* A current view of the Clubhouse entrance. The Administration building has been shuttered for several years now. The paddock area was torn down in the 1960s and the grandstand and clubhouse buildings were connected. The race track is currently in negotiations to be sold and redeveloped into mix residential and commercial space.

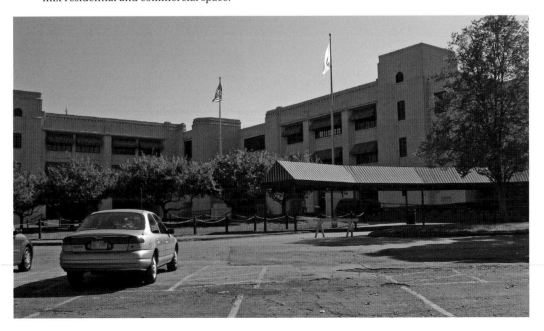

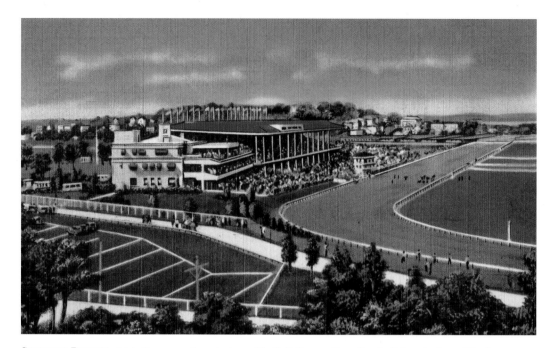

SUFFOLK DOWNS: A bird's-eye post card view of Suffolk Downs Race Track. *Below:* A view of Furlong Road with the Suffolk Downs Racetrack stable area in the background. This area was originally owned by Suffolk Downs and leased during the 1980s when the carnival was in town. Originally there was a driving range on this site that went out of business during the 1960s. Suffolk Downs Racetrack sold the land in 2004. The property was then developed. *Inset:* The road was moved and a strip mall was erected on the site in 2005. An additional plaza was built across from the first plaza in 2006.

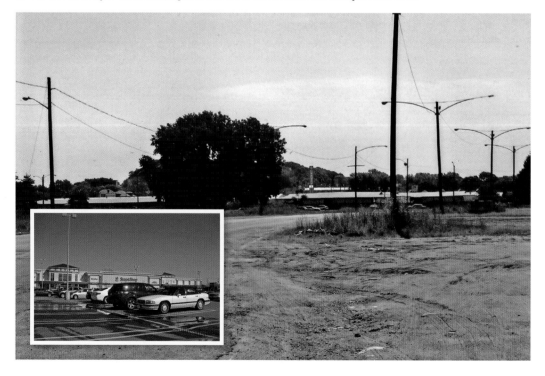

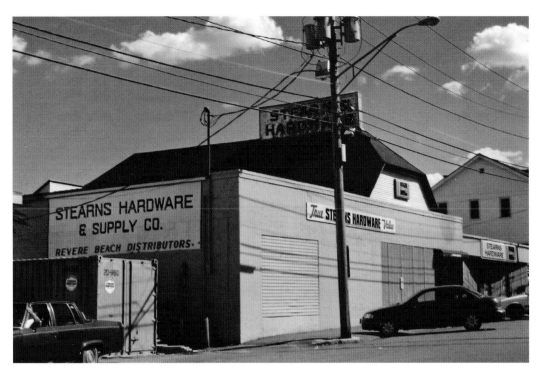

STEARNS HARDWARE: This business was located on North Shore Road. Stearns had been trading at this location since the 1950s. The portion of the building with the hipped roof was known as the pony barn. This was where the ponies were stabled that pulled the ice cream carts around the city up until the 1940s. Stearns Hardware closed in 2004. *Below:* A 2013 view of the former Stearns Hardware building, now being utilized by Family Dollar.

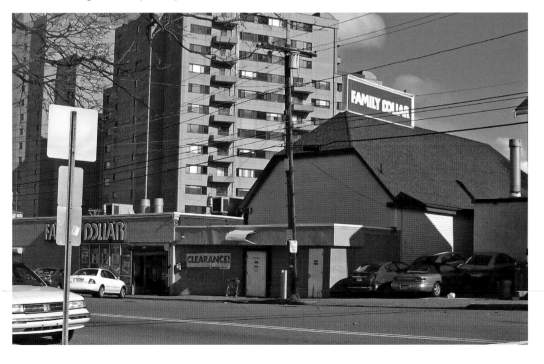

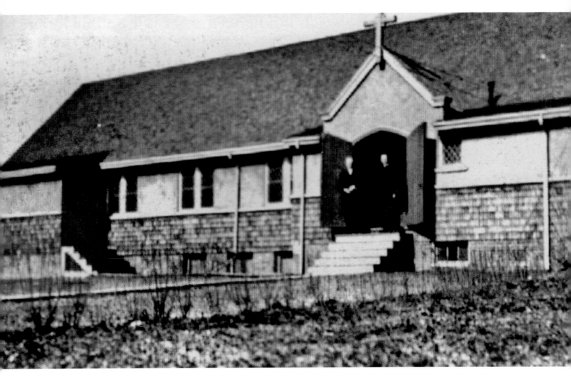

SAINT ANN'S EPISCOPAL CHURCH: In 1903 a building commission was formed and by 1910 Saint Ann's Episcopal Church was built on Beach Street. The church was consecrated by Bishop Lawrence on February 1, 1911. By the 1970s the congregation at the church had dwindled and the doors were closed. *Below:* A 2013 view of the former Saint Ann's Episcopal Church building. After the church closed the property was purchased and renovated into office space.

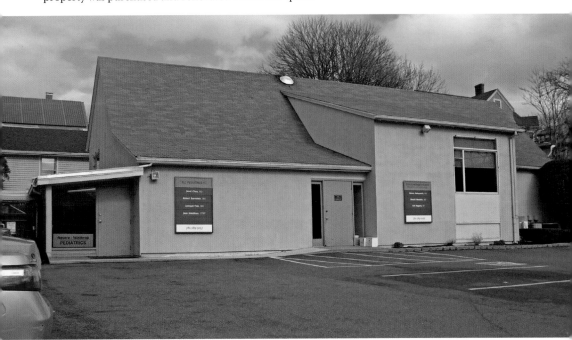

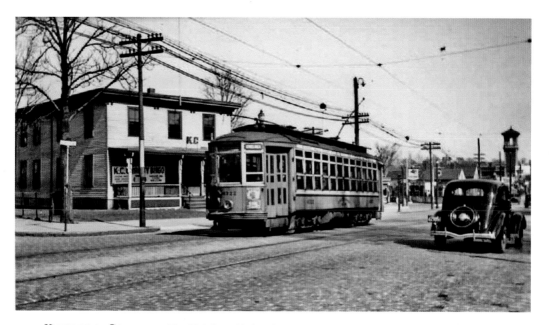

KNIGHTS OF COLUMBUS: The Knights of Columbus Hall was located on Broadway. Notice the gas station that is located next to the hall. Broadway was less crowded in the 1930s when streetcars dominated the main road. *Below:* This is the United States Post Office which is located on Broadway. The building was erected by the WPA sometime in the late 1930s. The post office once used the entire building until the 1990s when the post office retained a portion of the building and sold off the unused remainder. The unused portion was completely renovated and turned into office space.

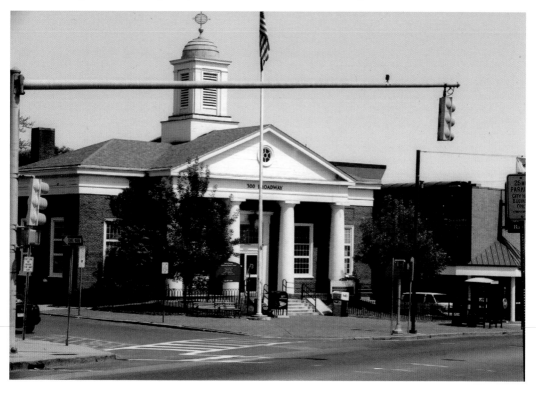

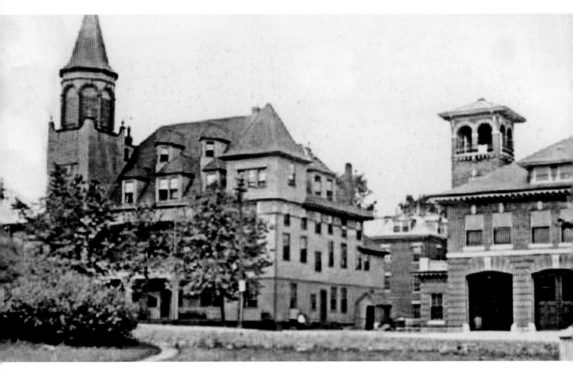

THE ASSOCIATE CHURCH AND LAY COLLEGE: The college was located on the corner of Walden Avenue and Shirley Avenue and was founded to train young men to become ministers. Also in this picture is the Walden Street Fire Station. *Below:* The fire station was closed in 2008. The city completely renovated the building and converted the property into low income elderly housing. This project has become a gem in the city for preservationists.

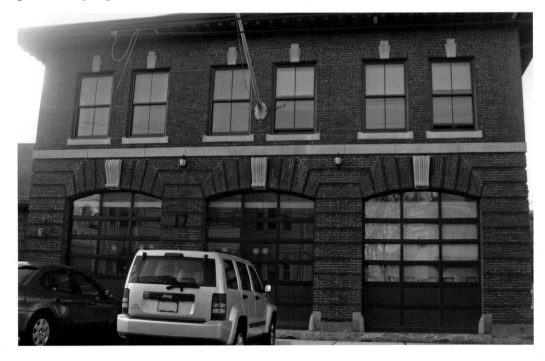

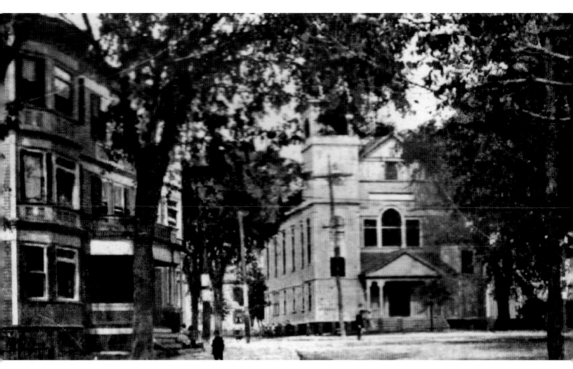

THE FIRST CONGREGATIONAL CHURCH: Originally this church in Church Square was an Orthodox church, built in the 1840s and officially dedicated on January 17, 1850. As the congregation grew so did the need for a larger church building. The church was raised and a vestry was added in 1884. On January 29, 1885 the church was rededicated and the name was changed to the First Congregational Church. *Below:* A 2013 view of the First Congregational Church. The church has been remodeled over the years, but it still retains much of its original character and charm. The congregation is still extremely active within the city.

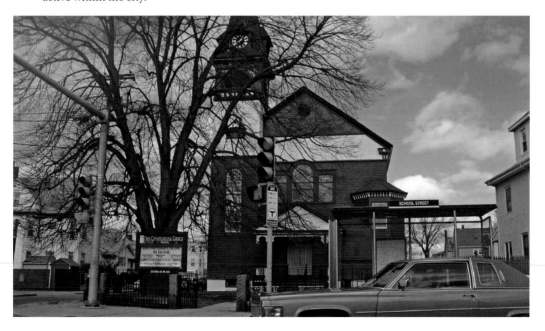

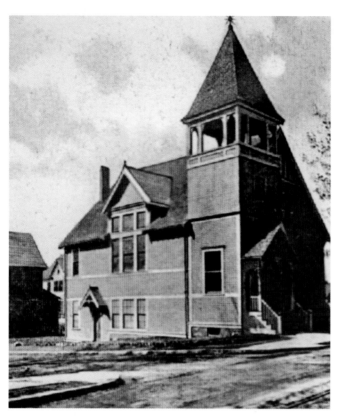

THE TRINITY CONGREGATIONAL CHURCH: The first church in Beachmont was begun by Almira Steele in 1878 and was held in a café that was owned by the Boston Land Company. The congregation was organized in 1881 under the name Union Evangelical Church. The name was changed again in 1897 to Trinity Congregational Church. Precisely when the church closed is not known to the author. The former church building has not changed much since it was built. It was renovated and is now used as a daycare center. The exterior of the building has been kept the same as it was when it was built.

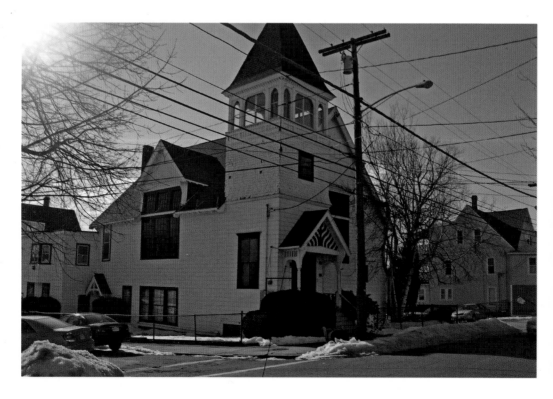

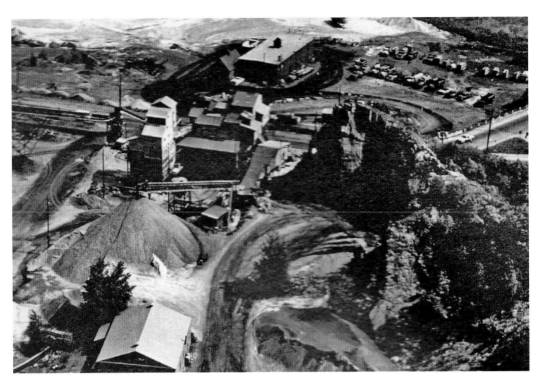

ROWES QUARRY: An aerial view of Rowes Quarry which was located on Salem Street in north Revere. The Quarry was operational until 2000, when the company was no longer able to quarry due to surrounding development. The operation was closed down and the equipment and land were sold. *Below:* After Rowes Quarry equipment was dismantled the site was developed into luxury apartments. Malden and Revere built a joint fire station on the property as the site sits on the divide between the two cities.

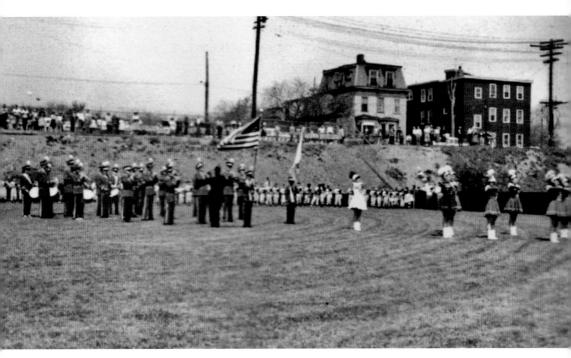

McMackin Field: This is a view of the field on its opening day in 1956. Revere Little League was formed in 1951 with Vincent Martelli as the first President and uncle to Tony and Billy Conigliaro. This field was purchased from the city. *Below:* McMackin field as it currently appears. This field has undergone extensive renovations throughout the years. In 1975, this was the first little league park to install lights for night games in Massachusetts. The field has gone unused for several years now while city officials debate its fate.

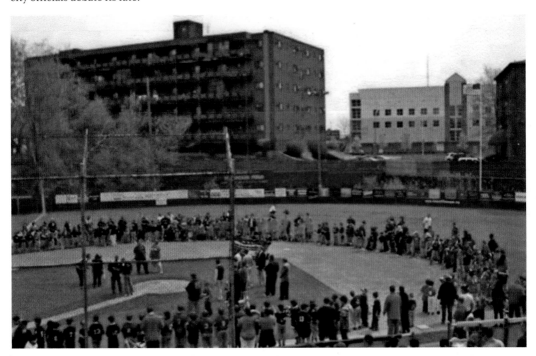

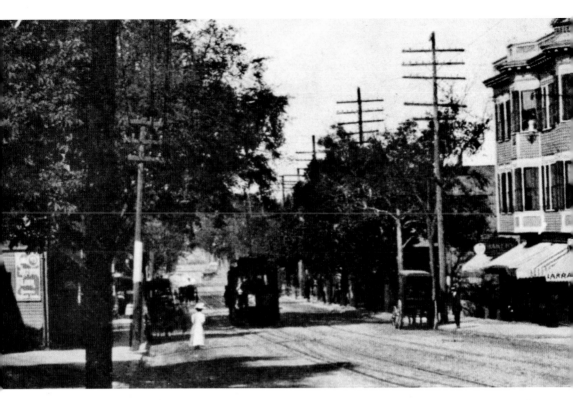

BROADWAY LOOKING SOUTH: The building on the right once housed the City Hall Pharmacy which operated in the corner store until the mid-1990s . At the time this photograph was taken Broadway still has apple orchards in certain areas. *Below:* A current view of Broadway. The building that once housed City Hall Pharmacy has been remodeled. Broadway today is a mecca for shopping and banking. Long gone are the apple orchards and the sparse buildings along the way.

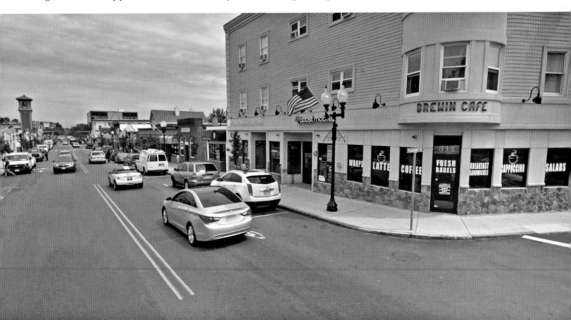

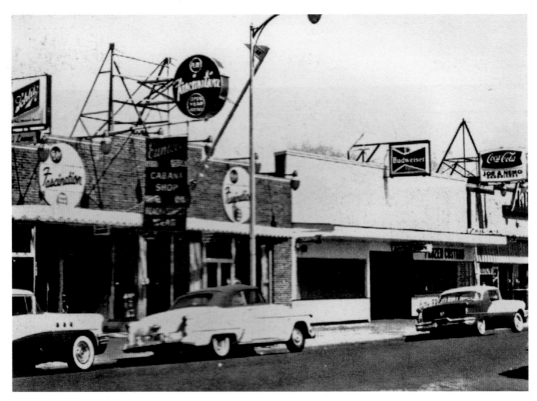

REVERE BEACH: By the 1950s Revere Beach had evolved from a handful of amusements and vendor stands strewn along the boulevard, into a world class resort. All these permanent structures operated from May 30th till Labor Day, when they would shut down for the winter.

THE FROLIC: The best known nightclub along the boulevard was the Frolic Theatre Restaurant. The Frolic was owned and operated by the Della Russo and Cella families. Originally it was a bar until it was purchased in the 1930s and was renovated into a world class entertainment complex. In the 1930s Louis Prima would broadcast nationwide during the 1930s from the Frolic. *Below:* A poor and grainy photo of the Frolic after the blizzard of 1978. The storm severely damaged the Frolic building making it structurally unsafe. The building was torn down a couple of months later. Never again would Revere Beach have entertainers like Jerry Vale, Barbara Streisand, and Sammy Davis Jr. to name just a few of the performers who graced the stage. *Inset:* An early 1950s evening photo of the Frolic Theatre Restaurant.

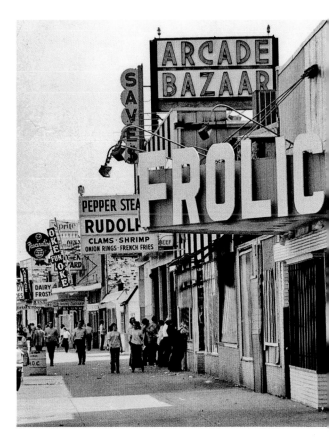

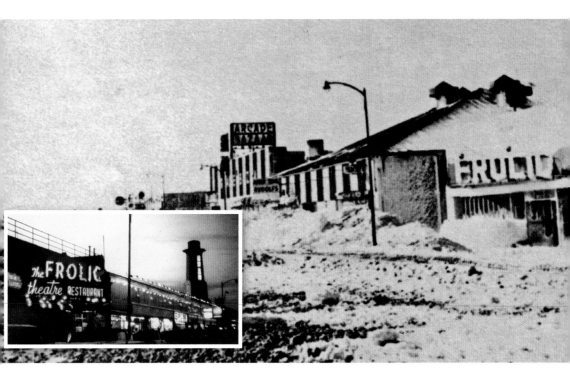

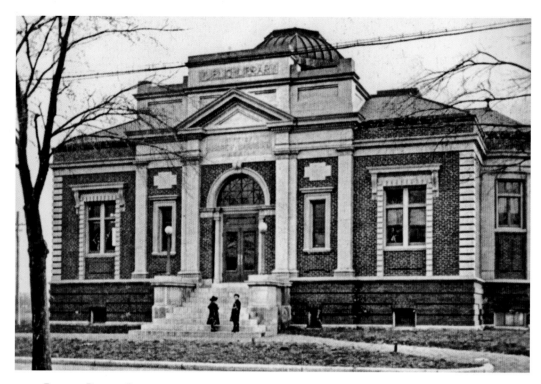

REVERE PUBLIC LIBRARY: The library was built in 1903 with a gift from Andrew Carnegie. The gift was $20,000 for the construction of the building with the stipulation the city would budget $2,000 annually for the library. The Revere Woman's Club formed in 1894, raised money to furnish the rooms of the new library. *Below:* A 2013 view of the Revere Public Library. This building has been in constant use as a library for over 110 years. It was completely renovated in the 1990s, but the exterior and interior of the building looks almost the same as the day it was built.

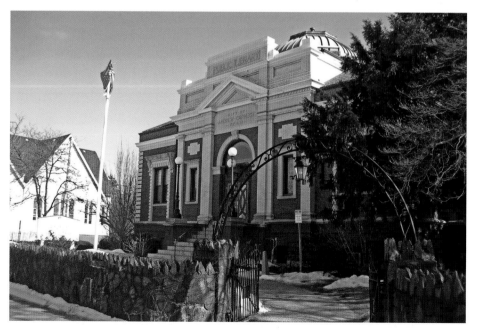

THE IMMACULATE CONCEPTION
RECTORY: Once the deal was finalized
between the city of Revere and the
Boston Archdiocese, concerned
citizens began to attempt to save the
former rectory. The building was in
serious disrepair and required total
rehabilitation. The Revere Society for
Cultural and Historic Preservation
entered into a 99 year lease and began to
repair the deteriorating structure. *Below:*
The former rectory as it looked in 2013.
The building was rehabilitated through
fund raising efforts, grants and private
donations. The building currently
houses a museum which is run by the
Revere Society for Cultural and Historic
Preservation. The building has also
been placed on the National Register of
Historic Places.

IMMACULATE CONCEPTION CONVENT FOR THE SISTERS OF SAINT JOSEPH: This building was the original convent for the sisters who taught in the parish school. The building was torn down in the 1960s when a new convent was built. The school parking lot now occupies the site. *Below:* This is the new convent that was built in the 1960s to house the Sisters of Saint Joseph. By 2005 the Sisters of Saint Joseph no longer occupied the building. The Immaculate Conception School has since begun to utilize some of the rooms in the building.

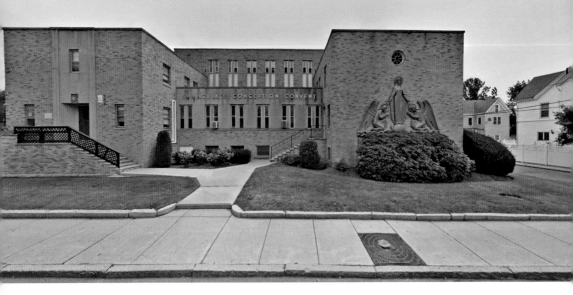

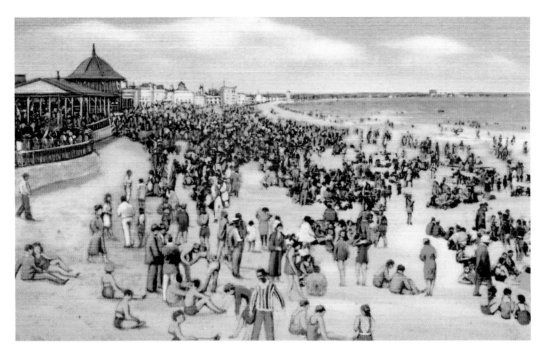

REVERE BEACH: A color postcard with a crowded beach. *Inset: from left to right:* Leo McGrath, John Craig, Carolyn Craig and Joan Gutmann frolicking in the water at Revere Beach in 1935. *Below:* Revere Beach as it looks today. No longer do large crowds gather on the shore and ride the thrill rides and amusements along the boulevard. Gone too are the elaborate ballrooms and first class nightclubs with famous crooners appearing nightly. All that remains are memories of the wonderful summers past. *Courtesy Diderot, Wikimedia Commons*

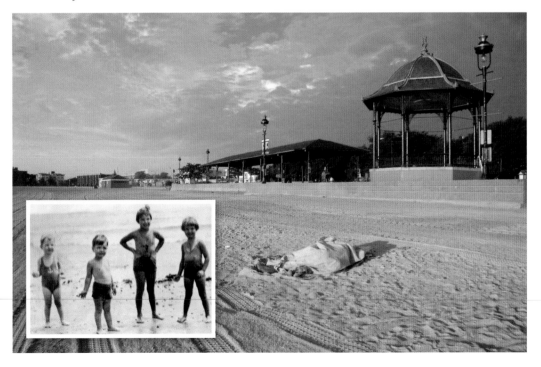

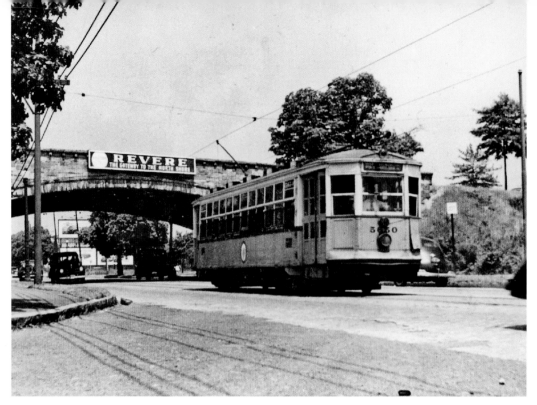

CASSASA MEMORIAL BRIDGE: A view of the bridge before it was widened to accommodate the increased traffic from Revere Beach Parkway. The bridge is named in honor of Andrew Cassasa the first Italian Mayor of Revere. *Below:* The same view taken during the present day. The streetcars no longer travel from Chelsea to Revere along Broadway, buses now do the job. For all the changes the city of Revere has undergone, many areas of the city remain untouched over the years.

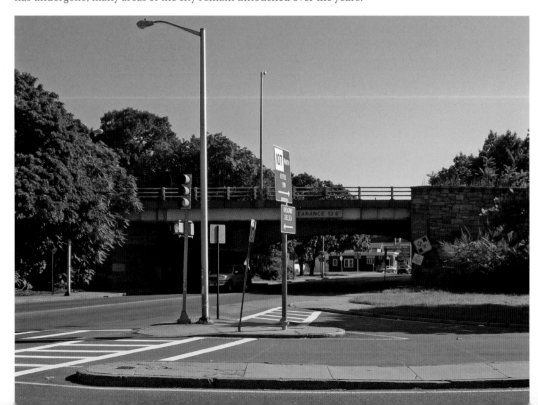